Islamic Art in the Kuwait National Museum

The al-Sabah Collection

Islamic Art in the
Kuwait National Museum

Edited by Marilyn Jenkins

Sotheby

© 1983 Nasser Sabah al-Ahmad al-Sabah
First published in 1983 for Sotheby Publications
by Philip Wilson Publishers Ltd
Russell Chambers, Covent Garden, London WC2E 8AA
Design consultant Charles F.Ryder
Typography Gillian Greenwood
Photography Gordon H.Roberton and Simon J.Roberton of A.C.Cooper Ltd, London
Printed in the United Kingdom by Jolly & Barber Ltd, Rugby
and bound by Woolnough Bookbinders Ltd, Wellingborough
ISBN 0 85667 174 6

ENDPAPERS
Design from a carved and painted wood panel, Egypt,
eighth century AD (illustrated on p 45)
LOGO
Design from a steel roundel, Iran,
probably eighteenth century AD (illustrated on p 136)
Art work for endpapers and logo David Penney

Contents

Foreword

In the name of God, the Merciful, the Compassionate

My interest in the heritage of Islam began when my father sent me to school in Jerusalem where I visited the holy places and learned to appreciate the greatness of their architectural design and the beauty of their decoration. While living there, I also had the opportunity to observe the walls, gates and water system of the Eternal City, all of which testified to the scientific knowledge and the technical skills of the Muslim craftsmen.

My vision of the Islamic past, reinforced by many visits to other historic cities of the world of Islam: Damascus of the Umayyads, Baghdad of the Abbasids, Fatimid Cairo, Saljuq Konya, Fez, Granada, Qayrawan, San'a, Delhi, Bukhara to mention only a few, remained simply a vision, until my wife Hussa, with her enthusiasm and perseverence, encouraged me to translate this vision into reality and to begin collecting Islamic art. From 1975, when I acquired my first pieces, my love for Islamic art continued unabated until I had acquired more than 20,000 objects of various kinds.

My decision, and that of my wife Hussa, to place our collection under the aegis of the Kuwait National Museum was made after consultations and discussions with many colleagues and friends. Once agreement was reached and the building within the Kuwait National Museum complex to house the Islamic collection was decided upon, the date for the opening had to be set. There did not seem to be a more auspicious occasion for the opening of this part of the Museum than the country's National Day. The resolve shown, particularly by my wife Hussa and by Dr Marilyn Jenkins of the Metropolitan Museum of Art in New York and her colleagues, made it possible to mount this exhibition in spite of the very limited time available. I hope those who visit it will judge it kindly and will pardon us if it is not yet in an ideal form. It is our hope that over the years it will attain a position with the great museums of the world.

The collection touches on every important aspect of the artistic culture of Islam, with the aim to be as comprehensive as possible. It includes manuscripts, medical instruments, works of metal, glass, wood and ivory, and any kind of object which relates to the scientific and practical life of Muslims. Its emphasis is first of all on the spiritual bonds which unite the Muslim peoples and the artifacts which express them – manuscripts of the Qur'ān, inscriptions on mosques, mihrabs and qiblas – and second on the common factors which have formed their culture. If there are gaps, the reason is that these objects were not originally collected in order to illustrate a continuous historical line, but were chosen for their beauty or their importance. When I acquired them, it was not my intention to display them publicly.

Yesterday these objects were scattered in Europe and America and other distant parts. Now they are nearer to their places of manufacture, allowing those who live here to see the products

of their great civilisation of the past. It is my hope that they will be viewed and examined by as many people as possible. The collection includes a considerable number of objects which have not yet been published, and the exhibition will give historians and specialists in the history of art opportunities for study and research. Much has been written about various aspects of Islamic civilisation, but there are large areas within the history of the decorative arts still to be investigated. May this collection provide an artistic dictionary by means of which the unique beauty of the arts of the Muslims can be better understood.

This book includes only a selection of the holdings of the Museum's Islamic collection and we hope with God's help to publish many more of them in the near future.

In conclusion, I should like to extend my warmest thanks to all those who have helped to arrange and display the collection in its present form and to prepare this book.

Nasser Sabah al-Ahmad al-Sabah
KUWAIT, 1982

Editor's note

In the winter of 1981 Sheikh Nasser asked me if I would help him create a museum in Kuwait from his collection of Islamic art, a museum he wanted to open on 25 February 1983. With the blessing of the Metropolitan Museum of Art and the support of its director, Philippe de Montebello, I accepted; and thus began one of the most challenging as well as academically stimulating years of my life. In asking me to direct the work on this superb collection from the numbering, measuring and cataloguing of its objects to their conservation, photography, publication and exhibition, Sheikh Nasser afforded me a unique privilege for which I shall be eternally grateful.

On the occasion of the publication of this book, which is intended both as an introduction to the al-Sabah Collection as well as a commemorative volume marking the opening of the new Museum of Islamic Art in the Kuwait National Museum, I would like to take the opportunity to thank a number of individuals whose contributions are such that they should not remain anonymous. First among these is Sheikha Hussa Sabah al-Salem al-Sabah whose help and moral support were inestimable. Katie Marsh and Elizabeth Richardson both provided immeasurable assistance in details large and small; Yousra Abdulla Said Awad, Walter Denny, Nobuko Kajitani, David King, Linda Komaroff, Louise W. Mackie, Maan Z. Madina, Yasin H. Safadi, Robert Skelton, Priscilla P. Soucek and Oliver Watson all made themselves readily available when their scholarly advice was sought, and Albert Hourani, Basim Musallam, John O'Neill and Joan A. Speers were most generous with editorial comments.

Marilyn Jenkins
NEW YORK, SEPTEMBER 1982

Introduction

Sheikh Nasser did not begin collecting Islamic Art with a view towards establishing a museum. Not only is his humility too great to ever have imagined that his acquisitiveness would eventually have resulted in a museum, but his collecting appears to have been born primarily of the desire to bring Islamic objects back to Islamic soil. Now that almost 1000 objects from his collection fill the Museum of Islamic Art of the Kuwait National Museum, I am sure he is more incredulous than anyone.

In slightly less than eight years, a man with a desire to bring back objects created by a particular culture (which is, in fact, his own) within the geographical confines of that culture has managed to do what no other single individual has ever done – create a Museum of Islamic Art. Not restricted to any one period, area or medium, it is the largest comprehensive collection in the Islamic world and ranks with the other great collections of this art in Berlin, Leningrad, London, New York and Paris, each of which is the result of the efforts (often spanning more than a century) of many people.

Sheikh Nasser is an inveterate collector and an intuitive connoisseur with a highly refined taste, trained eye and photographic memory. He has a boundless enthusiasm which sustains him during the sometimes long pursuit of an object, a coolness which stands him in very good stead during its capture and a genuine love for beautiful things in general and Islamic art in particular which is reflected in the manner in which he cares for and lavishes attention on an object once it is his.

He combines this passion for collecting and for the art itself with an essential humility, a magnanimity and a disarming personality notable for an infectious charm, ingenuousness and a delightful sense of humour.

Finally, when a mere pastime becomes a mission with the consequent added demands such a transformation makes on one's time, the spirit with which the mission is undertaken is strongly affected by the support of those in one's immediate family. Sheikha Hussa has been a constant inspiration as well as help to her husband throughout his years of collecting.

The history of Islamic art has a unity which is remarkable considering its inherent diversity given its development over a period of 1300 years and its spread from Spain to the borders of China. One of the reasons for this cohesion is to be found in four characteristics of this art: the decorative use of geometric patterns, highly stylised vegetal forms, figural iconography and calligraphy. This unity is, however, not simply a measure of the pervasiveness of four basic characteristics. What is equally contributory is the cyclical repetition of certain processes

throughout thirteen centuries which insures a continuity over such a long time and wide space. Each of the four broad chronological periods into which the objects illustrated here have been divided incorporate most or all of the following: adoption, adaptation, creation, imitation, migration and continuation or revival.

Our knowledge is limited about the art enjoyed by the economically sophisticated and wealthy mercantile aristocracy in the three major Arabian cities of Mecca, Medina and Ta'if when the Arabs began their conquests in the name of Islam during the second quarter of the seventh century AD. It is clear, however, that whatever form this art took, it appears not to have played an appreciable part in the Muslim cultures which developed later outside the Arabian peninsula.

In the early years of Islam, most of the building styles, architectural decoration, decorative techniques, types and shapes of objects, as well as iconography were adopted from the cultures found in the areas conquered by the Muslims, and it was only gradually that this adoptive process became first adaptive and finally creative. The late Greco-Roman tradition was prevalent on the shores of the Mediterranean at the time of the Arab conquests. Formal modes were added to the naturalism of this tradition by means of the stylised motifs of Sasanian origin which were prevalent in the more eastern areas conquered by the Muslim armies – namely Iraq and Greater Iran.

While all three processes of adoption, adaptation and creation are present during the Early Islamic Period (seventh to tenth century), the first two are the most commonly found.

Geometric patterns were very much a part of the late Greco-Roman tradition. Building on this, Islamic art ultimately developed the decorative possibilities of geometry in the most intensive and imaginative way in all of world art history. Those patterns used during the Early Islamic Period, however, give little indication of the inventiveness which was to characterise this decorative mode starting in the subsequent period. For the most part, Muslim artists of this time seem to have been content to use patterns taken from the tradition they inherited. The geometric interlace design on the carved and painted wood panel (p45) illustrates this adoption quite beautifully.

Vegetal designs were used in a variety of ways both in the Roman/Byzantine world and in pre-Islamic Iran. The progressive abstraction of such motifs during the Early Islamic Period can be followed on three objects in the al-Sabah Collection. The ivory box (p32) bears quite a faithful rendering of the late Greco-Roman design of an urn sprouting vine scrolls complete with grapes. The decoration on the marble capital (p44), on the other hand, while still paying lip-service to the tradition from which it grew is developed from that on its pre-Islamic models. Finally, the *tabula ansata* on a page from a Qur'ān manuscript (p21) bears a vegetal design exhibiting a formalisation known as an arabesque in which one leaf grows out of the tip of another forming an unending, continuous pattern which seems to have neither a beginning nor an end.

Calligraphy has always been considered the highest art form in the Islamic world and as such has absorbed the efforts and displayed the talents of some of the best of Islam's artists. The

continuous and almost unprecedented number of transformations which Arabic writing was to undergo began in the Early Islamic Period and the al-Sabah Collection has examples of the early *mā'il* (p18) and western (p19) and eastern (p20) Kufic scripts. The decorative use of calligraphy on objects in various media also began at this time (pp23, 29, 42 and 44), that on the textile fragment being an early example of the often confounding liberties taken with the alphabet for purely decorative purposes.

Perhaps the lustre-painted earthenware bowl (p22) epitomises the artistic creativity of the time better than any other single object illustrated from the period. Used to decorate glass from as early as the middle of the eighth century (p29), the application of the technique of lustre painting to pottery was the single most important contribution made to the ceramic industry in the Early Islamic Period. Its spread to the new medium in ninth-century Iraq was an event which was to make a permanent imprint on the ceramic industry in general and its echo is still being felt in the lustre-painted ware produced in the West today. That the technique as well as particular designs found on Iraqi lustre-painted ware spread to Egypt during this period is witnessed by the bowl (p26).

During the Early Medieval Islamic Period (eleventh to mid thirteenth century), it is the creative process which takes precedence, although adoption and adaptation continue to serve as important cohesive factors.

The decoration on the bottle (p58) as well as the method of its creation, by blowing the blue glass into a two-part mould, illustrate both the adoption of a technique prevalent during the Early Islamic Period and the continuity of an arabesque design found on objects in various media from the ninth-century Abbasid capital of Samarra. The Egyptian rock crystal chess pieces and bottle (pp60 and 61) exhibit closely related designs with a similar Iraqi heritage indicating that the motif moved westward during this period as well as to the east.

Another glass technique adopted from the previous period is used to decorate the perfume sprinkler (p59, right). The process of imbedding glass threads in a matrix and combing them to create a pattern originated in pre-Islamic Egypt.

The *repoussé* technique employed to execute the animal decoration on two bronze candlesticks (pp70 and 71) and prevalent on Sasanian metal vessels was not commonly used by Islamic metalworkers. They preferred linear designs created by chasing or engraving which in general tended to replace the relief designs of pre-Islamic Iranian metalwork. The vegetal and calligraphic decoration on the Egyptian lampstand (p66) is a fine example of chasing, a technique which was also in use during the Early Islamic Period.

Used sparingly earlier, the practice of adding colouristic nuances to metalwork through the inlaying of gold, silver and copper attained its zenith during this period. Such work is epitomised here by the octagonal candlestick (p70) which is inlaid with silver and copper and successfully combines vegetal, figural and calligraphic decoration.

The new technique of enamelling and gilding used to decorate glass during this period (p59, left) was to enjoy great popularity during the following period as well.

Experimentation in the field of ceramics led to an important innovation during this period – the rediscovery of Egyptian faience. This man-made as opposed to naturally occurring substance is a mixture of potash, quartz and white clay. It was not long before this white, composite body was being used as a ground for painted designs exhibiting greater line and tonal variety than was possible before. The victory over this medium was thus achieved and the decorative possibilities open to the Muslim potter were now limitless. The graceful ewer (p53) is a masterful example of the potter's new control over his medium.

Having disappeared from Iraq never to return to the best of our knowledge, lustre painting on pottery continued in Spain as well as in Egypt during this period. It is from the latter country, with the disintegration of the Fatimid dynasty and the rise of artistic patronage under the Kurdish Ayyubids and various Turkic groups including the Zengids and the Great Saljuqs, that it most probably moved to Syria (p51) and Iran (p54).

The tendency to experiment, which was to characterise the art of calligraphy throughout its history in the Islamic world, continued in the Early Medieval Islamic Period. This creativeness can be seen in the manner in which the shafts of the letters terminate in palmette leaves in the Qur'ān section (p49) that contains one of the most beautiful examples of eastern Kufic script known. This ingenuity is further evidenced by the repeated wish for يمن (happiness) hidden among the dense foliage on the earthenware plaque (p55).

Figural iconography which was used sparingly in the Early Islamic Period played an important decorative role during the subsequent period, especially under the Fatimids in Egypt and the Great Saljuqs in Iran. The finely drawn head (p50), the veritable zoo on the hunting horn (p63), the colourful Bactrian camels on the bowl (p56) and the zoomorphic handle (p72) (to point out only a few of the many such examples to be seen here) illustrate the importance of this feature at this time. Many of the figural scenes are vignettes of courtly life providing us with pictures of enthroned rulers giving audience, court musicians and royal pastimes of hunting, polo playing and falconry. Genre scenes also occur, all of which combine to give us an invaluable glimpse of life during the Early Medieval Islamic Period.

Except for the creativity in geometric decoration, the Late Medieval Islamic Period (mid thirteenth to fifteenth century) seems best characterised as one of adoption and adaptation, as well as one marked by a series of international styles created as a result of the displacement of artists after the Mongol invasions and later those of Timur.

The element of adoption can be seen on the lustre-painted pottery (p84) and enamelled glass of the period (p88). One of the manifestations of the process of adaptation at this time was the simplification of earlier traditions, and the gold element (p91) which lacks the granulation so prevalent on the gold jewellery of eleventh-century Egypt and Syria is a good and beautiful example of this. Adaptation also manifested itself during this period in the elaboration and refinement of earlier traditions. This process is particularly evident in the art of miniature painting. The miniature (p101), more in the Timurid than Safavid tradition, provides ample proof of the element of traditionalism in this medium at this time as well.

As regards the four basic characteristics of Islamic art, the preference for figural motifs which was so pronounced in the preceding period now shifts to that for calligraphic designs and elaborate geometric patterns. The interest in calligraphic designs is to be found on almost all forms of art. The preferred script is *thulth*, a majestic cursive style which lends itself very well to the robust and often large objects so prevalent at this time (pp94, 95 and 110). The Kufic script, however, was still an important decorative element and can be seen gracing one of the few existing complete Mamluk garments (p105). During the fourteenth, fifteenth and early sixteenth centuries, Egypt, under the patronage of the Mamluks, seems to have been the most creative and inventive with geometric patterns. The marble mosaic niche with two such designs (p106) and the carpet (p103) are important examples of the use of this decorative element.

The result of artists being forced or summoned to move their ateliers from one centre to another can be seen in the strong similarity between the Persian dish (p80) and the Syrian albarello (p81). While the relationship of fourteenth-century Syrian lustre-painted pottery to that of fifteenth-century Spain has not been adequately explained, the vase (p84) and the albarello (p86) are proof of a connection between the two industries. An international vogue in metalworking techniques and styles is also in evidence during this period with movement originally proceeding from Iran westward to Iraq, Syria and Egypt, but later in the period moving from west to east as well.

When one turns to the Late Islamic Period (sixteenth to eighteenth century), the processes of adoption and adaptation still serve as important cohesive factors unifying the art of different areas within the Islamic world. Rather than simply causing the styles and techniques of one country to be imitated in another, as was seen in the preceding period, the movement of artisans at this time led to these styles and techniques being adapted by the newly-arrived as well as local artists to suit local taste. This period was one of glorious renaissance but the seeds of decline which had been sown in the Late Medieval Islamic Period began to bear fruit and by the end of this period, Islamic art was for all intents and purposes enervated.

The Safavid medallion carpet of which the al-Sabah Collection has a magnificent example (p140) presumably grew out of a type current in Iran in the fifteenth century of which no known examples survive but a depiction of which occurs in miniature paintings. It was this type of carpet which influenced the design of the 'Medallion Ushaks' of Turkey (p146) and a style of bookbinding current in both countries (p134).

The effect of Persian artists being taken to India during the reign of Humayun and to Turkey during that of Selim I is seen in the art of miniature painting. A fine example of this cross-fertilisation is the Mughal portrait of a Persian artist (p139).

The tradition of hard stone carving has a long history in India. As is witnessed by the depiction of the indigenous Ashoka tree on the hexagonal centrepiece (p124) and the floral designs on another centrepiece of a magnificent armband (p125) or the fluting of the graduated beads (p131), Mughal artists were capable of delicately carving one of the hardest of stones – the emerald.

The European artisans taken into the royal Mughal workshops as well as European artifacts arriving at the court may have been responsible for the introduction of the art of enamelling into India. The quality of the enamel made by Mughal craftsmen was extremely high (p127) and its production continued throughout the period.

A high point of creativity and refinement during this period was also achieved in the field of ceramics. Some of the finest pottery ever produced in the Islamic world was made between 1490 and 1700 in the Ottoman Turkish city of Isnik (ancient Nicea) (pp116–20). The influence of this important production centre on the ceramic objects made in seventeenth-century Iran appears to have been strong (p112).

By means of a thread with numerous strands, the objects made for the Umayyad caliphs and those made for the Safavid shahs, Ottoman sultans and Mughal emperors are thus inextricably linked over the more than 1000 years which separates them. By using four basic decorative elements and continuously repeating the processes of adoption, adaptation and creation throughout thirteen centuries, the artisans of the Muslim realms caused the remarkable unity inherent in Islamic art to be attained in spite of the great diversity implied in its temporal and geographic expanse.

The collection introduced here is a living collection, one which will be augmented in years to come – its gaps filled, its weak areas strengthened, new masterpieces added. Thus, in time it will be even greater and more comprehensive than it is today. In forming this collection, Sheikh Nasser has greatly enriched the field of Islamic art, and in his decision to place it under the aegis of the Kuwait National Museum he has made an important cultural contribution to the world at large, the Middle East in general and Kuwait in particular.

Marilyn Jenkins
NEW YORK, SEPTEMBER 1982

Early Islamic Period

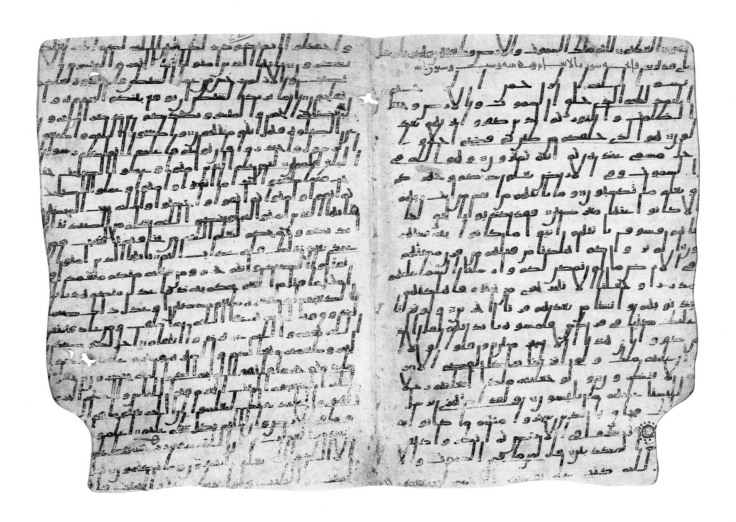

Double page from a Qur'ān manuscript
Ink on parchment
Probably Arabia (Mecca or Medina?), eighth century AD
Height 31.5 cm LNS 19 CAab

Two contiguous pages, beginning within verse 89 of Chapter V and continuing into verse 12 of Chapter VI

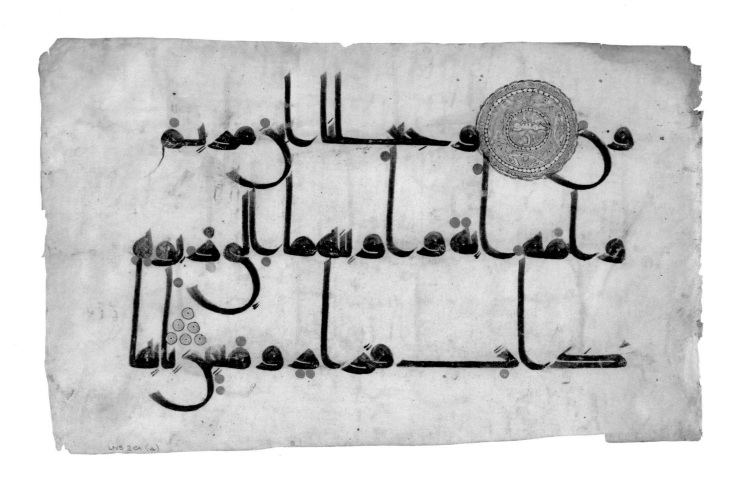

Leaf from a Qur'ān manuscript
Ink, colours and gold on parchment
Probably Tunisia (Qayrawān), first half tenth century AD
Width 30.7 cm LNS 2 CAᵃ

Recto begins within verse 49 and continues into verse 51 of Chapter XXIII; verso continues into verse 52

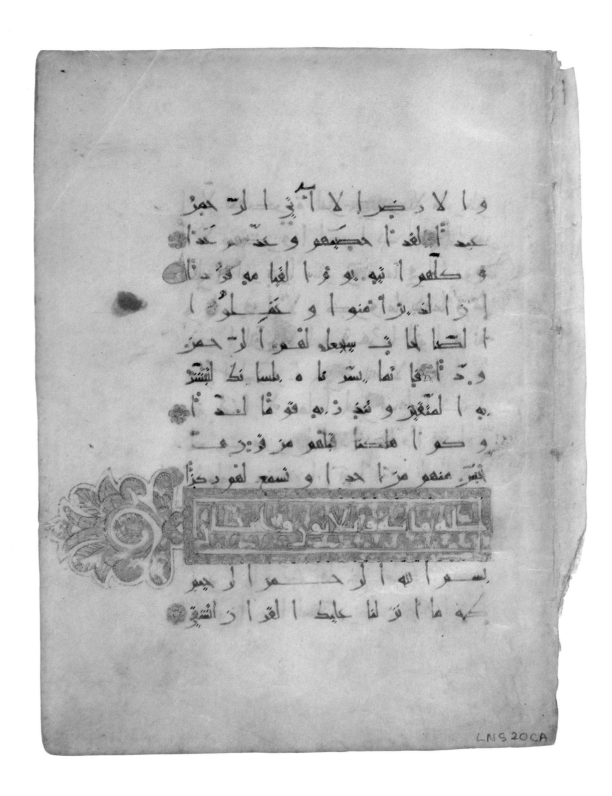

Leaf from a Qur'ān manuscript
Ink, colours and gold on parchment
Iran, first half tenth century AD
Height 15.5 cm LNS 20 CA

Recto begins within verse 93 of Chapter XIX and continues into verse 2 of Chapter XX; verso continues into verse 13

20

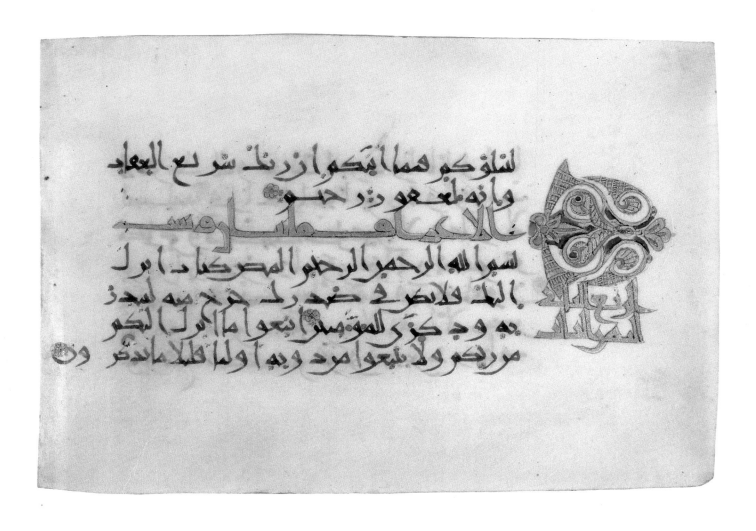

Seventh 'Juz'' from a Qur'ān manuscript
Ink, colours and gold on parchment
Tunisia, probably Qayrawān, second half tenth century AD
Height 13.3 cm LNS 65 MS

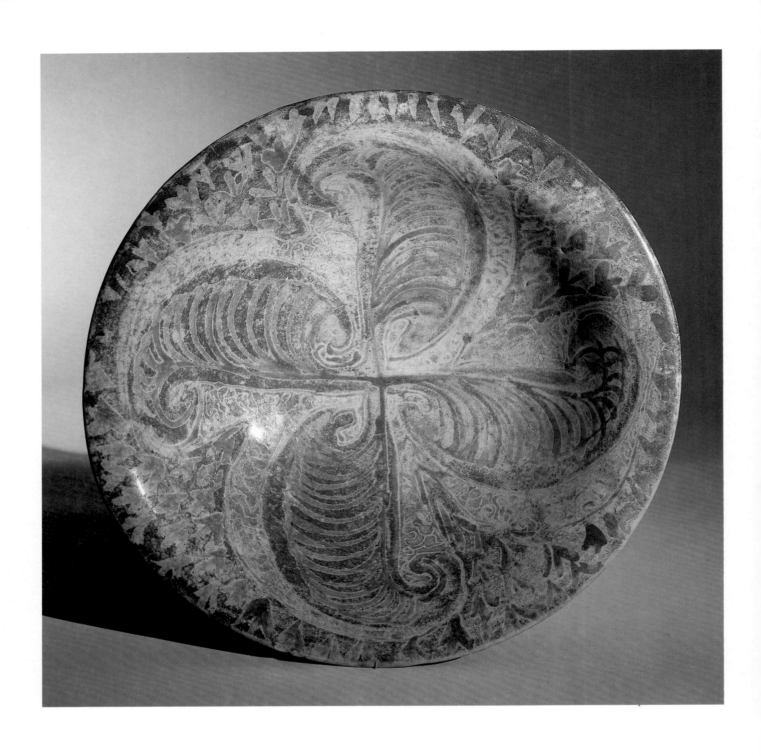

Bowl
Earthenware, glazed and lustre painted
Iraq, ninth century AD
Diameter 29 cm LNS 9 C

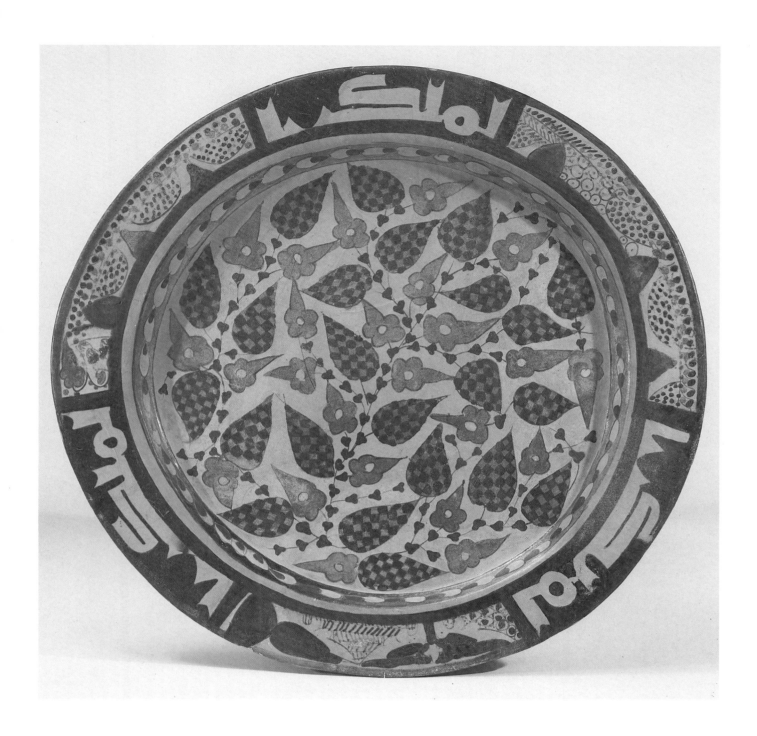

Dish
Earthenware, glazed and lustre painted
Iraq, ninth century AD
Diameter 37 cm LNS 98 C

INSCRIBED THREE TIMES
الملك *sovereignty*

23

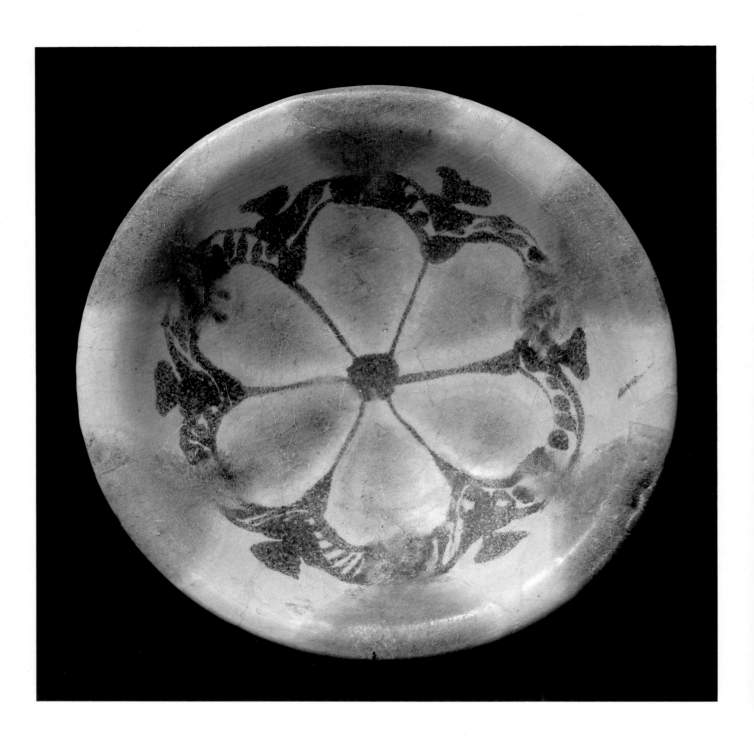

Bowl
Earthenware, inglaze painted
Iraq, ninth century AD
Diameter 16.2 cm LNS 110 C

24

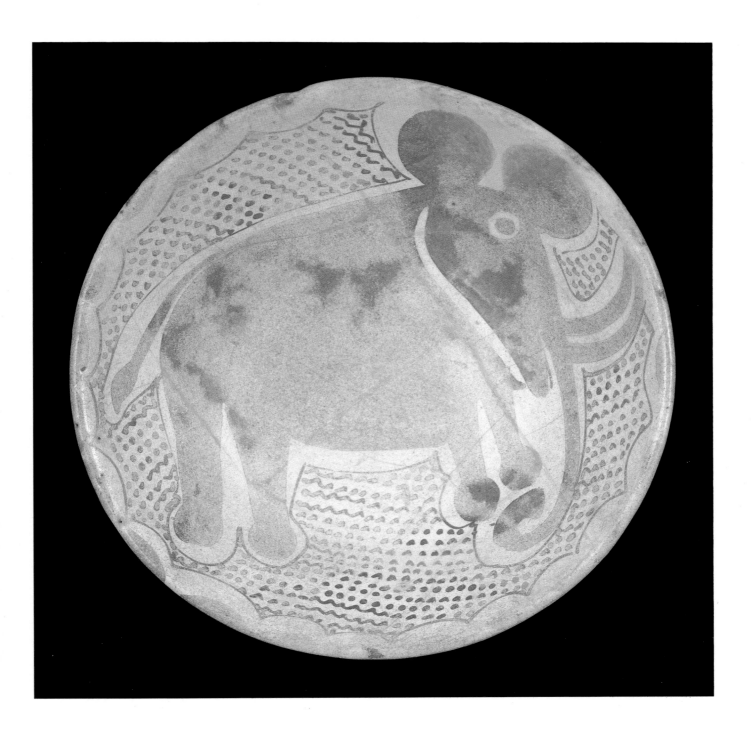

Bowl
Earthenware, glazed and lustre painted
Iraq, tenth century AD
Diameter 14.4 cm LNS 92 C

25

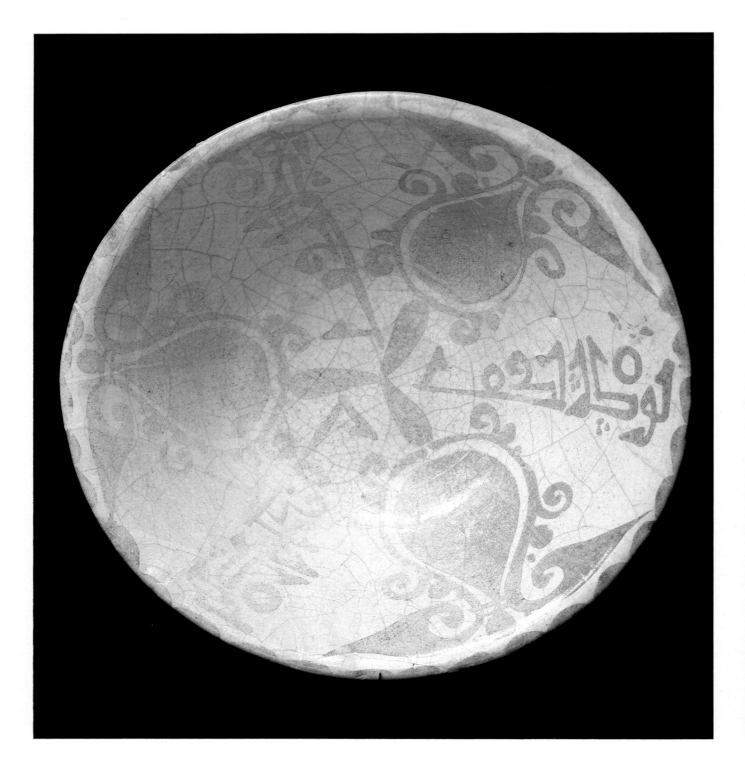

Bowl
Earthenware, glazed and lustre painted
Egypt, tenth century AD
Diameter 18 cm LNS 3 C

INSCRIBED
بركة لصا [حبه] *Blessing to its ow[ner]*

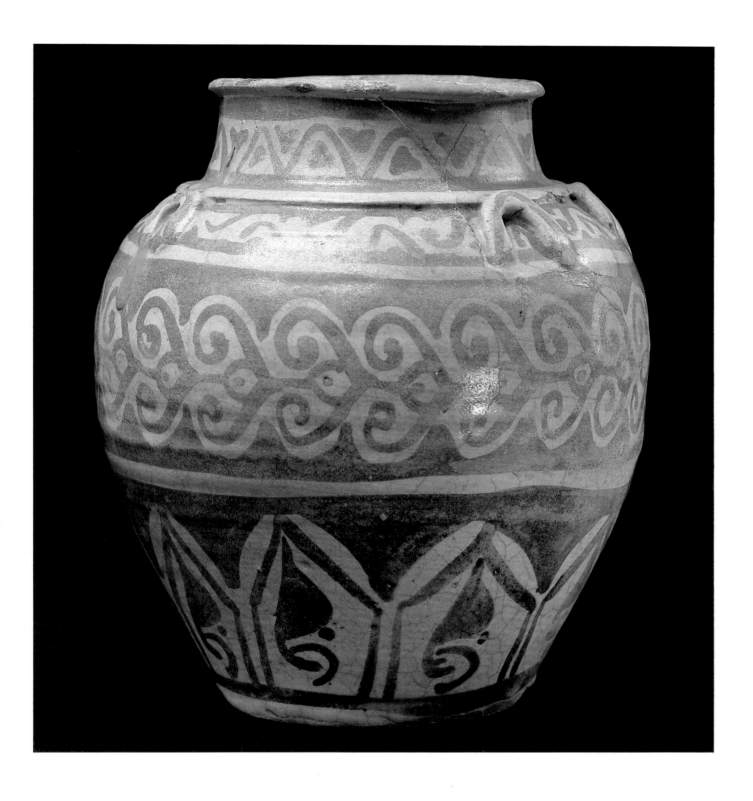

Vase
Earthenware, glazed and lustre painted
Egypt, tenth century AD
Height 22 cm LNS 90 C

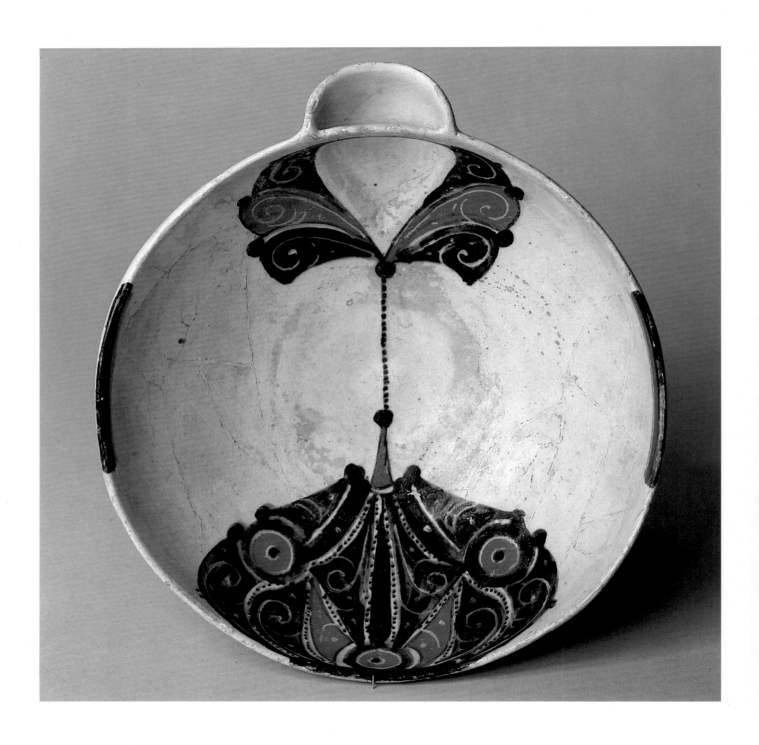

Bowl with spout
Earthenware, covered with an engobe, underglaze slip painted and incised
Iran, probably Nishapur, tenth century AD
Diameter with spout 21.3 cm　LNS 160 C

28

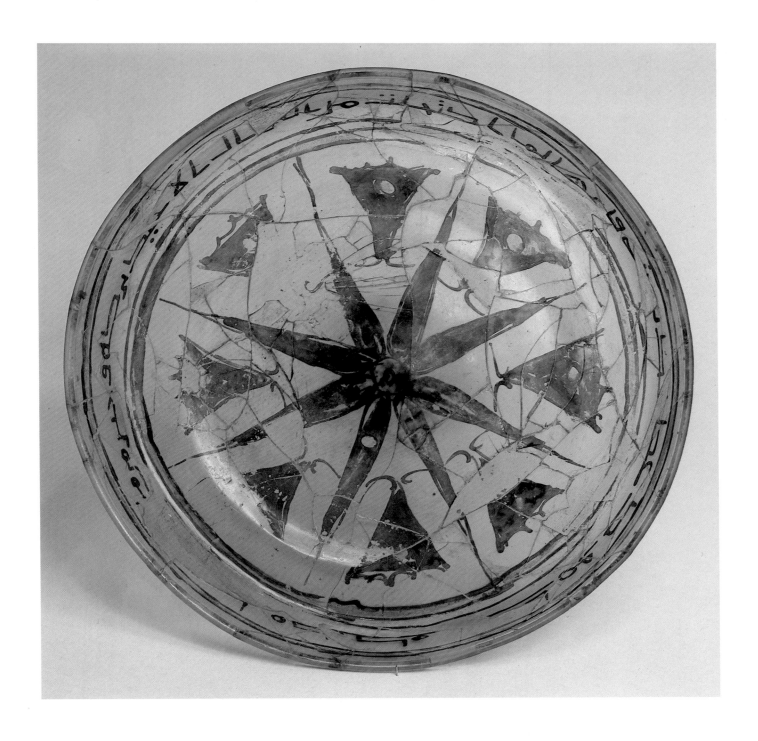

Dish
Glass, free blown and lustre painted
Probably Egypt, eighth century AD
Diameter 23 cm LNS 44 G

Inscription not deciphered, but contains the phrase
... بركة وخير من ... *... blessing and well-being from ...*

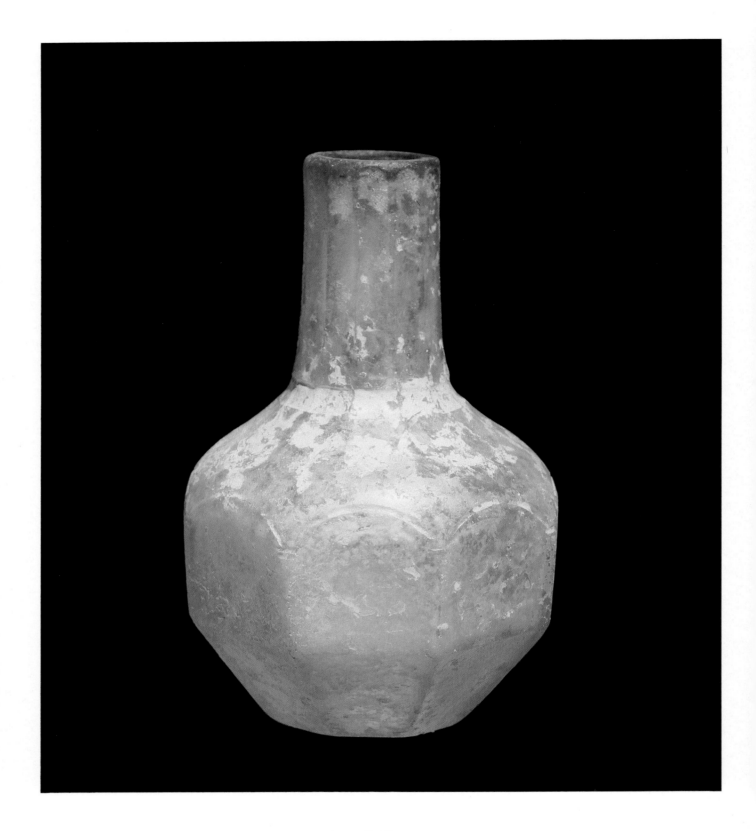

Bottle
Glass, free blown and lap and wheel cut
Iran, probably Nishapur, tenth–eleventh century AD
Height 12 cm LNS 67 G

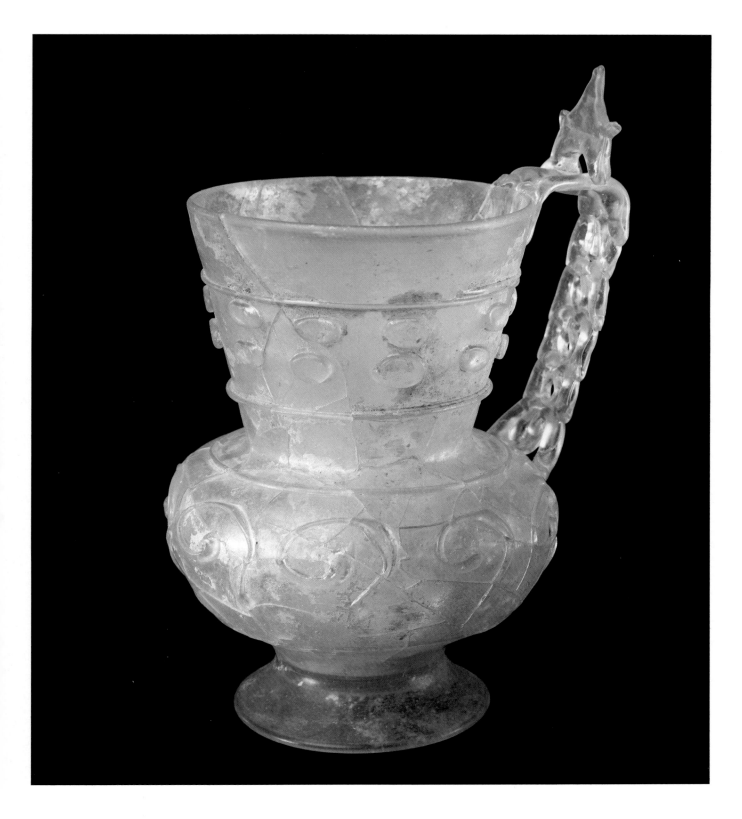

Ewer
Glass, free blown with plastically applied elements
Iran, probably Nishapur, tenth century AD
Height 15.5 cm LNS 43 G

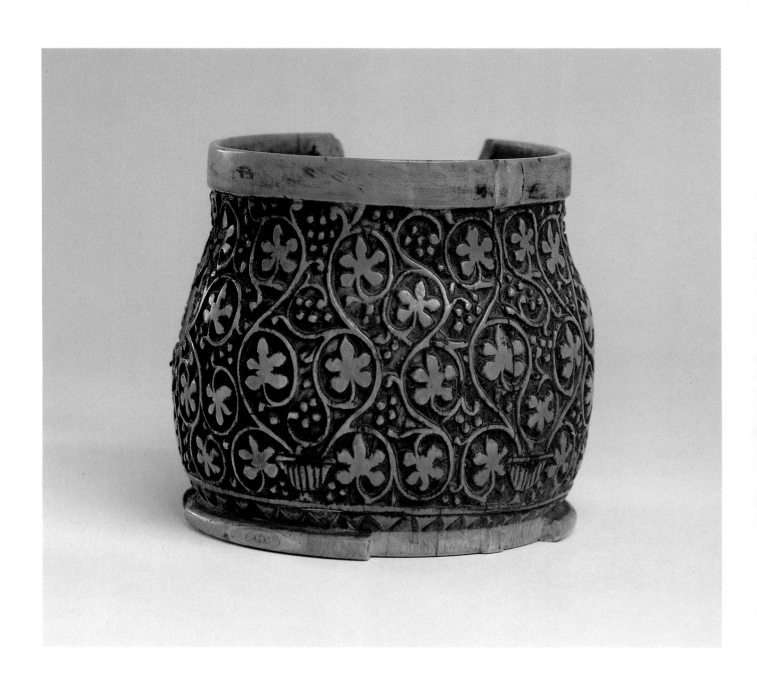

Box
(originally lidded)
Carved ivory
Syria (?), eighth century (?) AD
Height 8.5 cm LNS 181

32

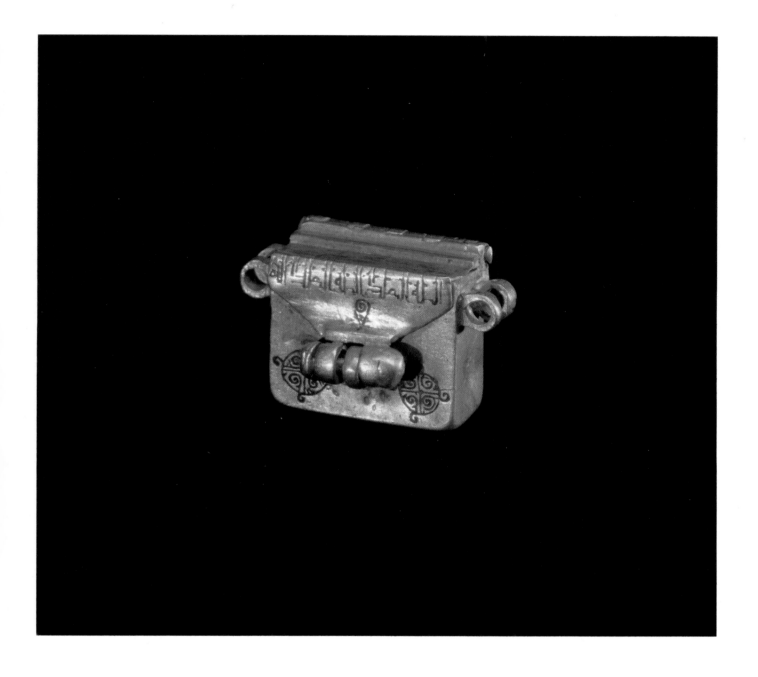

Amulet case
Gold, fabricated from sheet and wire, engraved and inlaid with black substance
Iran, tenth century AD
Height 1.6 cm LNS 33 J

INSCRIBED ON UPPER BACK OF CASE AND FRONT OF LID
Repetitions of
الله *God and* الملك *Sovereignty*
perhaps meant as the usual
الملك لله *Sovereignty belongs to God*

33

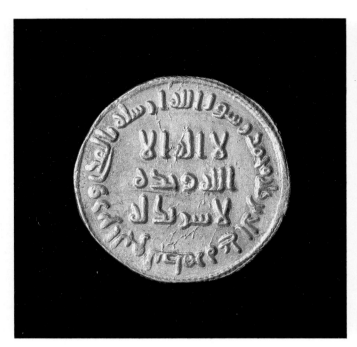 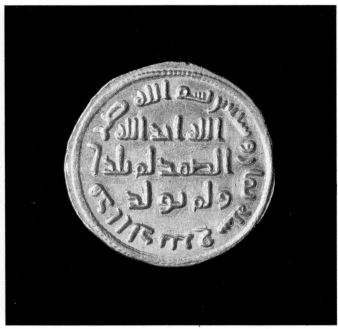

Dīnār

Gold

Syria, mint not named, but struck at Damascus, dated 78 AH/AD 697–98

Diameter 2 cm LNS 7 N

INSCRIPTION ON OBVERSE CENTRE

لا اله الا *There is no God but*
الله وحده *God alone*
لا شريك له *He has no associate*

ON OBVERSE MARGIN
Chapter X verse 33 of the Qur'ān

ON REVERSE CENTRE
Chapter CXII of the Qur'ān

ON REVERSE MARGIN
بسم الله ضرب هذا الدير (sic. for الدينار) في سنة ثمان وسبعين *In the name of God this dīnār was struck in the year eight and seventy*

34

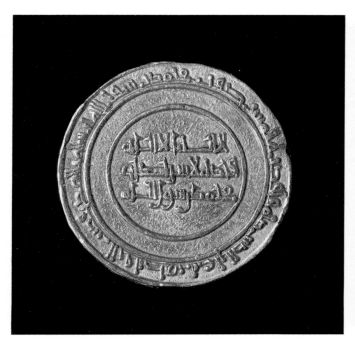
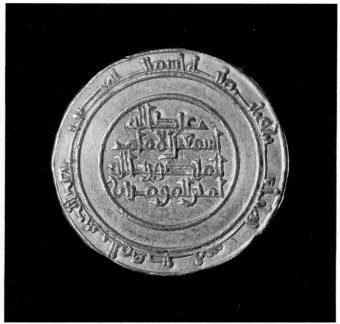

Dīnār
Gold
Tunisia, al-Mahdiyya, dated 340 AH/AD 951–52
Diameter 2.2 cm LNS 18 N

INSCRIPTION ON OBVERSE CENTRE

لا اله الا الله	There is no God but God alone
وحده لا شريك له	He has no associate
محمد رسول الله	Muḥammad is the messenger of God

ON OBVERSE MARGIN
Chapter X verse 33 of the Qur'ān

ON REVERSE CENTRE

عبد الله	The servant of God
اسمعيل الامام	Isma'il the Imām
المنصور بالله	al-Manṣūr billāh
أمير المؤمنين	Commander of the Faithful

ON REVERSE MARGIN

بسم الله ضرب هذا الدينر (الدينار sic. for) بالمهدية سنة أربعين وثلاث مائة *In the name of God this dīnār was struck at al-Mahdiyya [in the] year forty and three hundred*

35

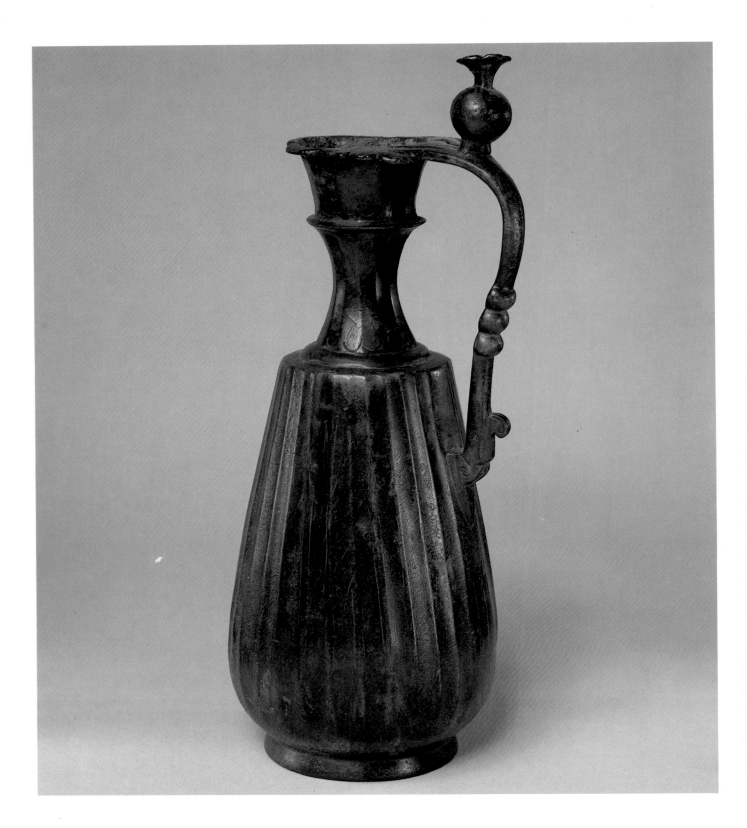

Ewer
Bronze, cast in one piece and engraved
Iran, eighth century AD
Greatest height 35.5 cm LNS 85 M

36

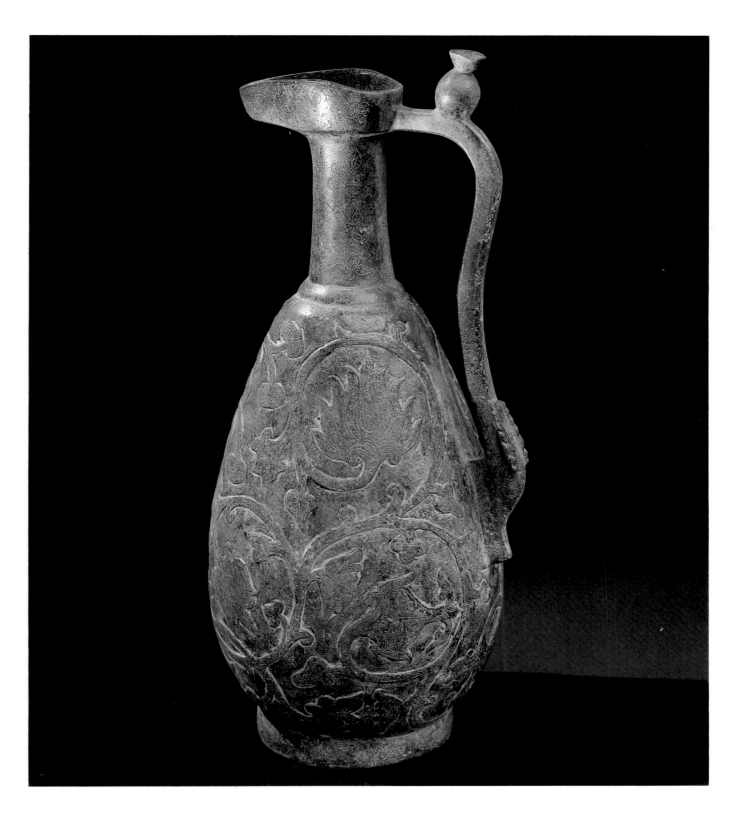

Ewer
Bronze, cast and engraved
Iran, eighth century AD
Height 25.5 cm LNS 84 M

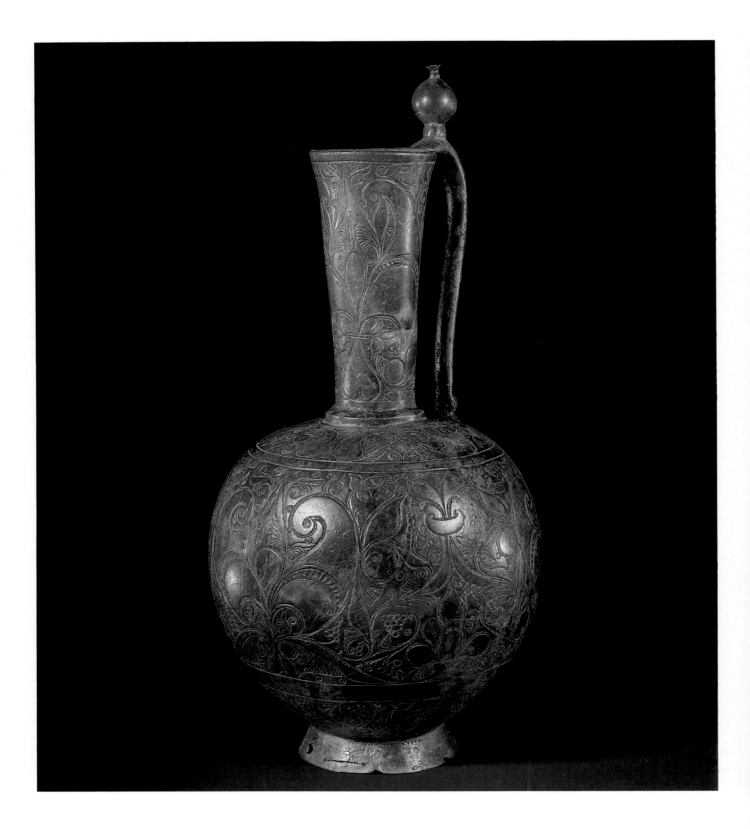

Ewer
Bronze, cast and engraved
Iran, ninth century AD
Height 29.2 cm LNS I 32 M

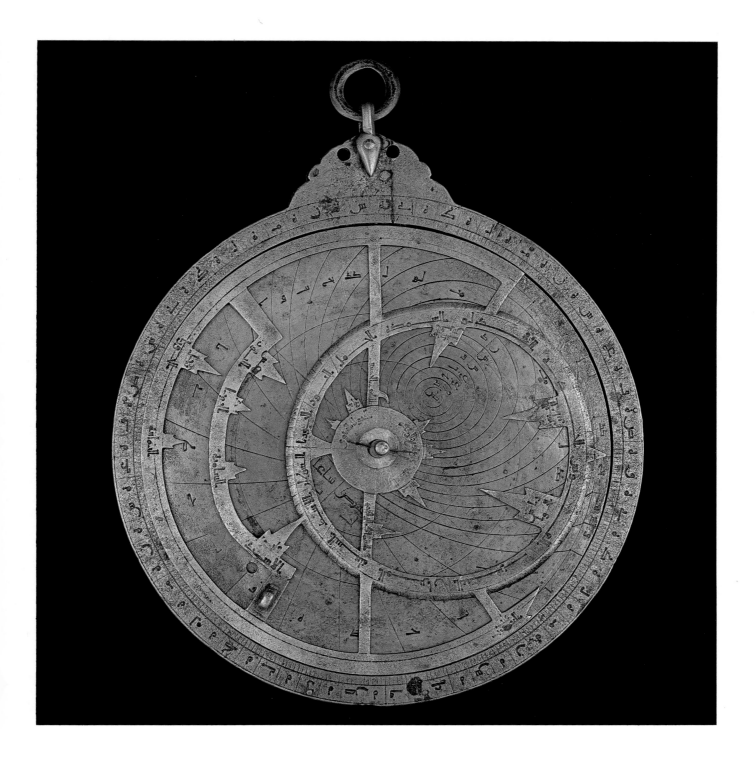

Astrolabe
Bronze, cast and engraved
Iraq, dated 315 AH/AD 927–28
Diameter 17.5 cm LNS 36 M

In addition to the purely functional inscriptions, it bears (on the back of the Kursī*) the following*
Work of Basṭūlus/[in the] year 315 صنعه بسطولس / سنة شىه

39

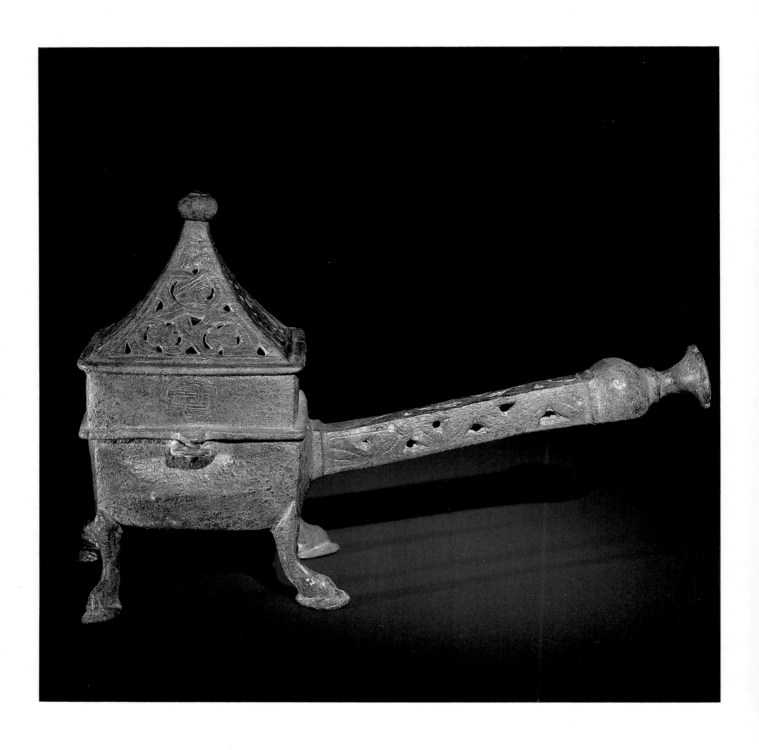

Incense burner
Bronze, engraved and pierced
Spain, eleventh century AD
Length 25 cm LNS 41 M

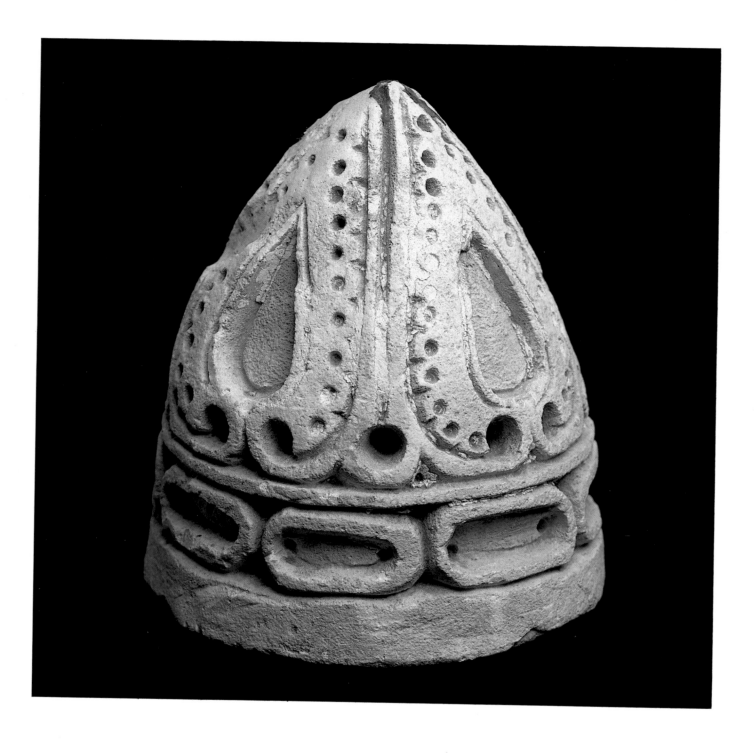

Bosse or finial
Stucco, carved and drilled
Egypt, ninth century AD
Height 18 cm LNS 1 ST

41

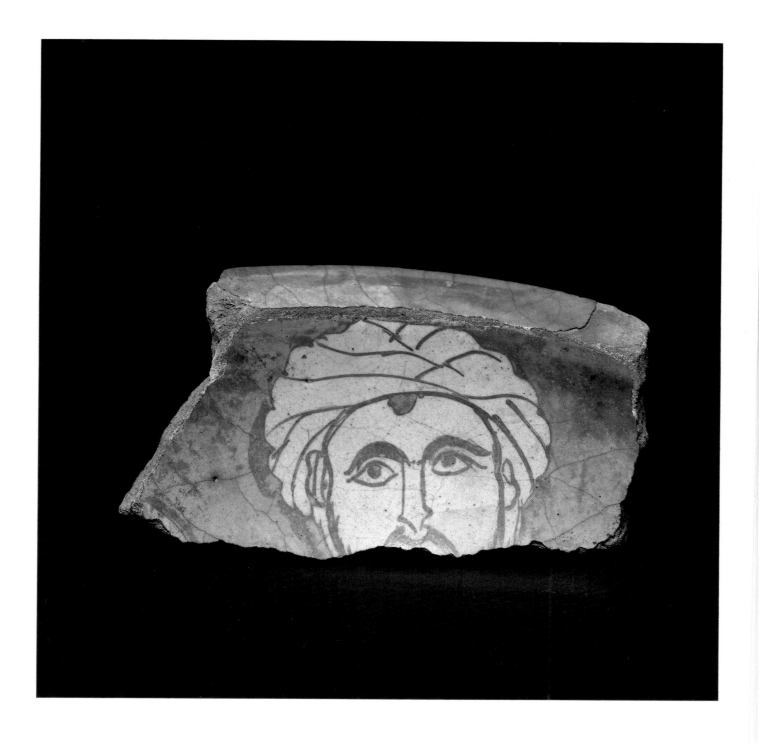

Bowl fragment
Earthenware, glazed and lustre painted
Egypt, eleventh century AD
Width 9.5 cm LNS 21 C

50

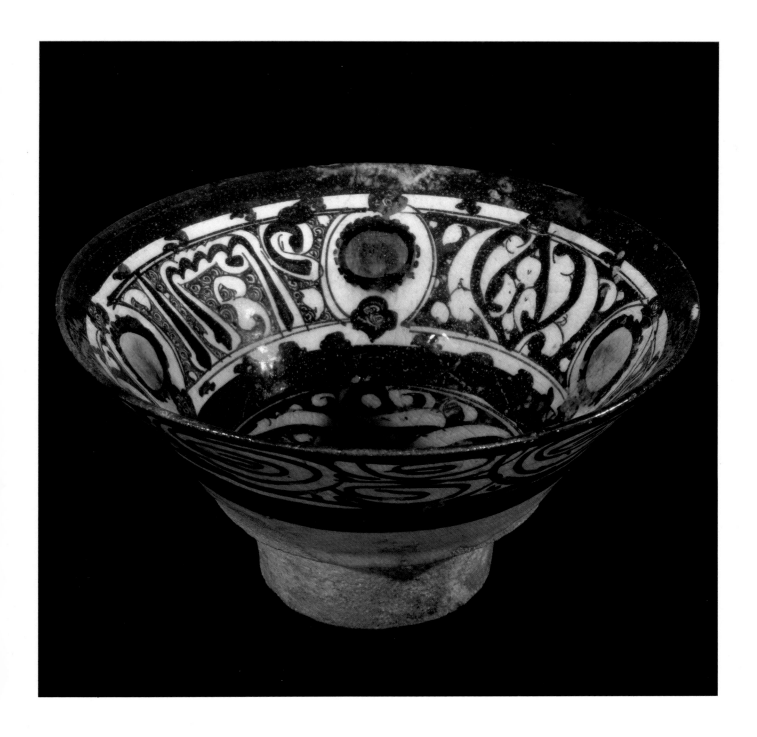

Bowl
Composite body, underglaze and lustre painted
Syria, late twelfth–first half thirteenth century AD
Diameter 24 cm LNS 24 C

INSCRIBED
السعاد [ة] الشاملة *Complete happiness*

51

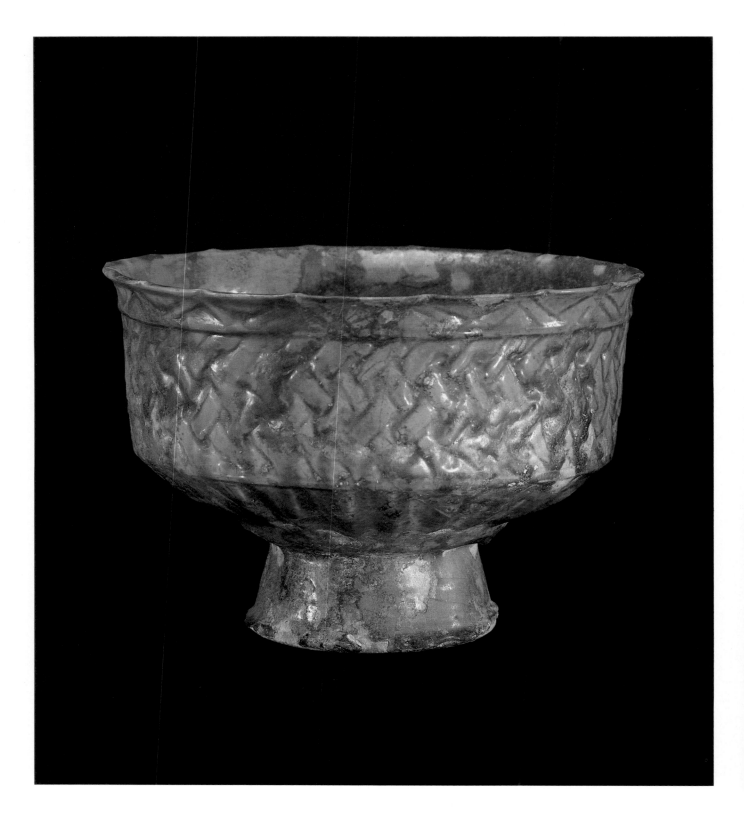

Bowl
Composite body, moulded and glazed
Syria, late twelfth–first half thirteenth century AD
Diameter 34 cm LNS 37 C

52

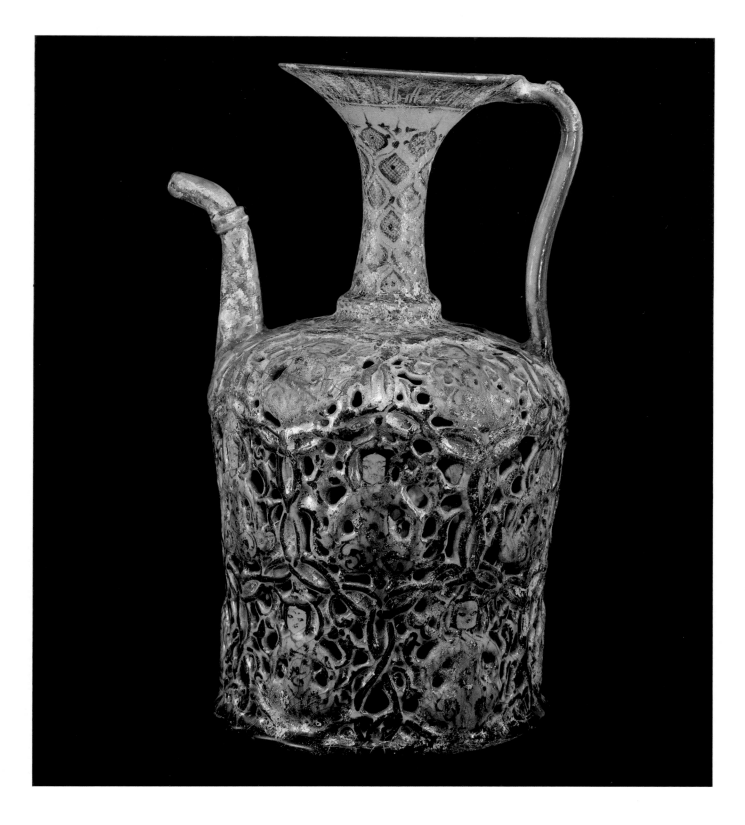

Ewer
Composite body, underglaze painted (glaze partially stained cobalt) with pierced outer shell
Iran, early thirteenth century AD
Height 30 cm LNS 185 C

53

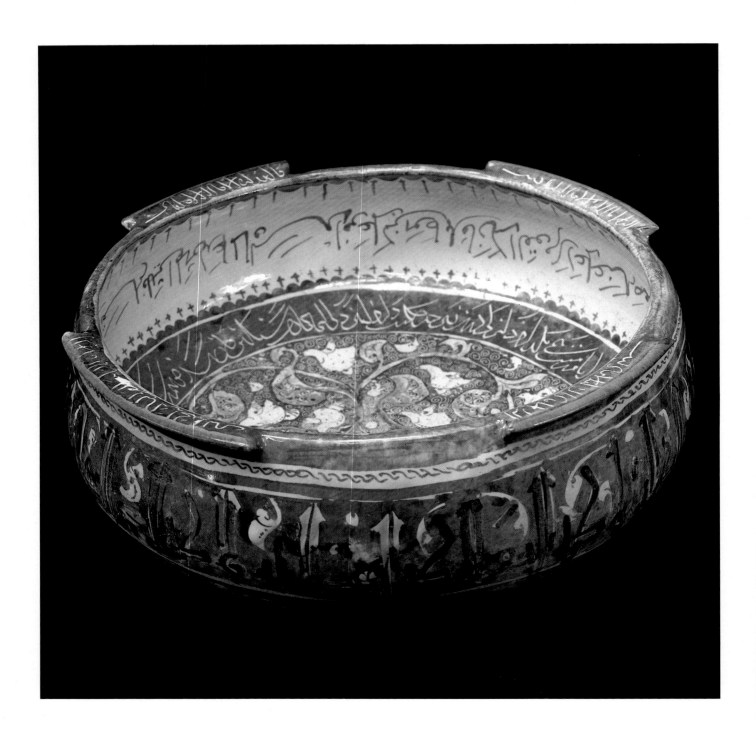

Bowl
Composite body, underglaze and lustre painted and incised
Iran, Kashan, dated Shawwāl 614 AH/January 1218 AD
Diameter 23.2 cm LNS 210 C

Undeciphered Persian and Arabic inscriptions

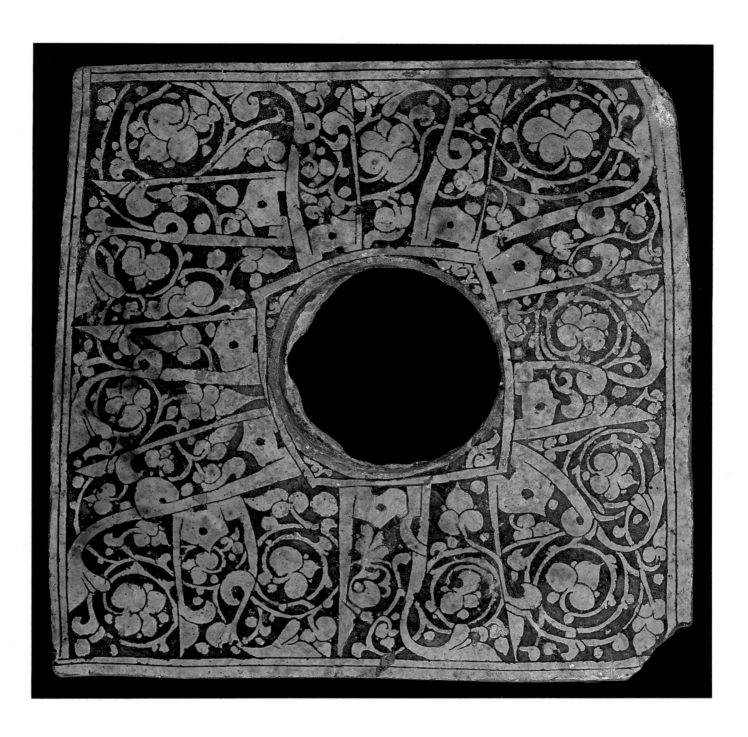

Plaque
Earthenware, white engobe, incised, glazed
Iran, second half twelfth–thirteenth century AD
Height 37.1 cm LNS 202 C

INSCRIBED REPEATEDLY
يمن *happiness*

55

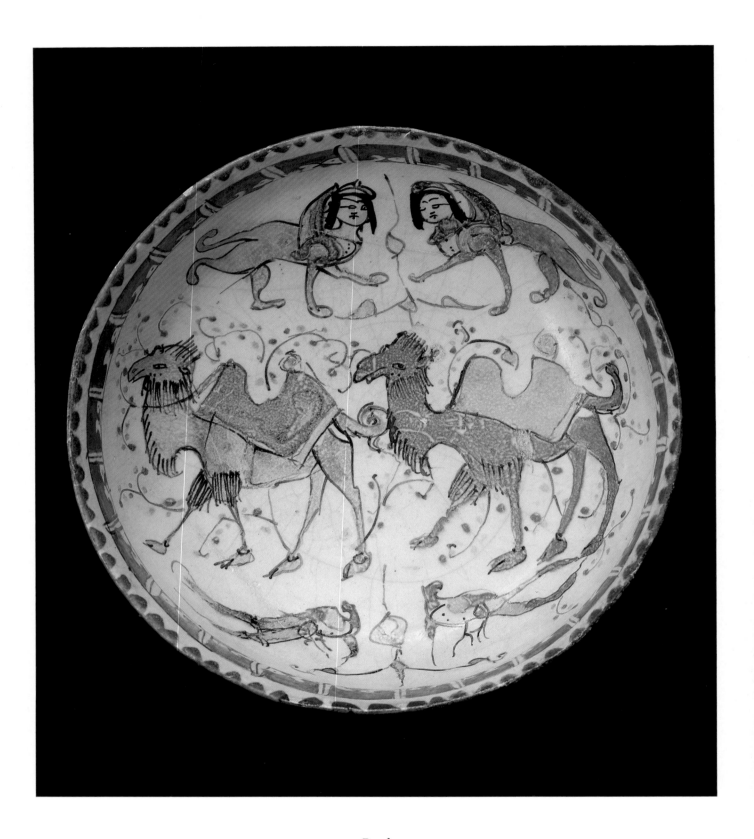

Bowl
Composite body, stain and overglaze painted and gilded
Iran, late twelfth–early thirteenth century AD
Diameter 15.5 cm LNS 108 C

56

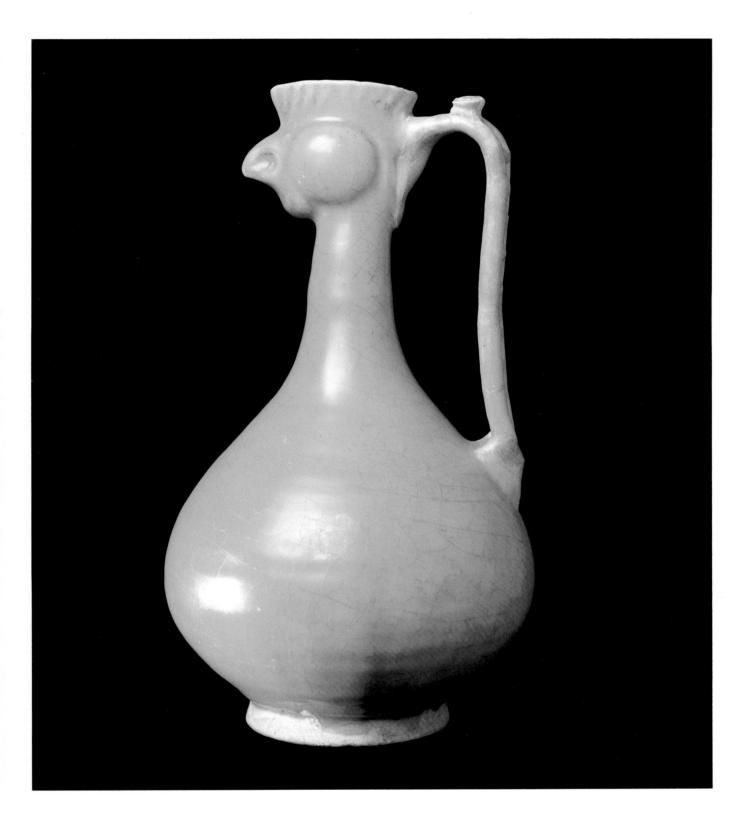

Ewer
Composite body, moulded and glazed
Iran, twelfth century AD
Height 26 cm LNS 93 C

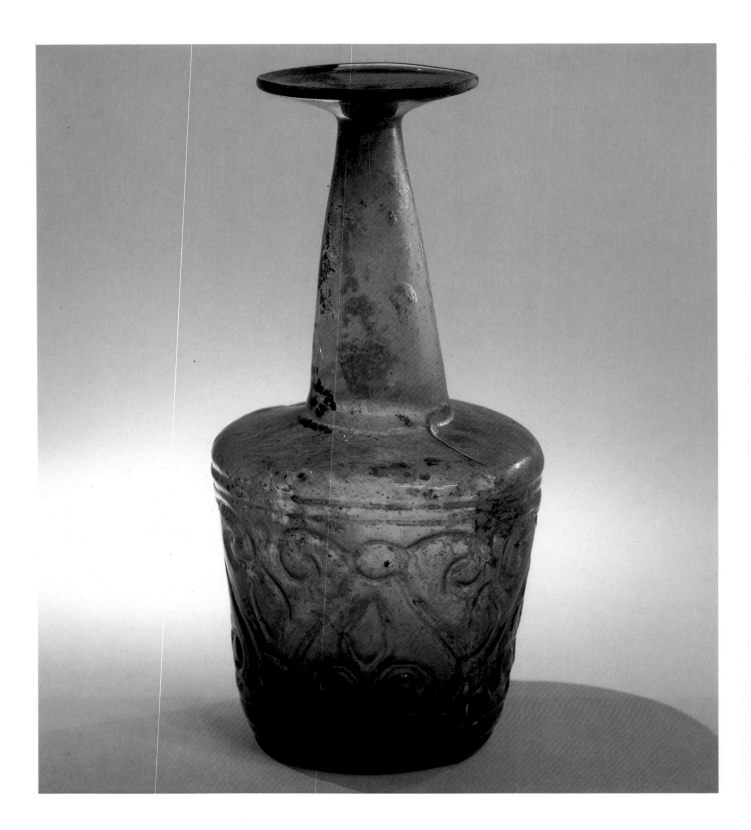

Bottle
Glass, lower part blown in two-part mould
Iran, eleventh–twelfth century AD
Height 27 cm LNS 8 G

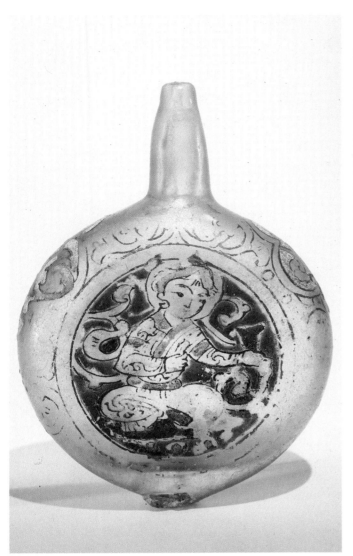

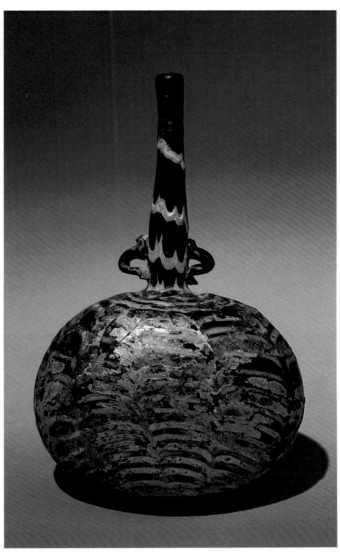

Perfume sprinkler
Glass, free blown and enamelled
Syria, thirteenth century AD
Height 11.8 cm LNS 48 G

Perfume sprinkler
Glass, free blown with plastically applied handles and
marvered and combed glass threads
Syria or Egypt, thirteenth century AD
Height 11.5 cm LNS 34 G

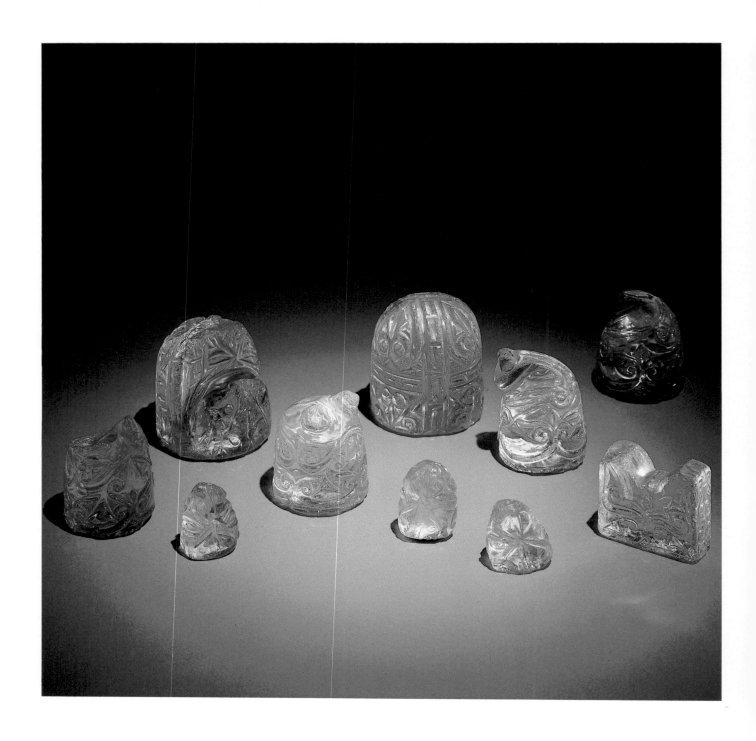

Ten chess pieces
Carved rock crystal
Egypt, tenth century AD
Greatest height 7 cm LNS I HSa–j

Two kings or viziers (queens), two bishops, two knights, rook and three pawns

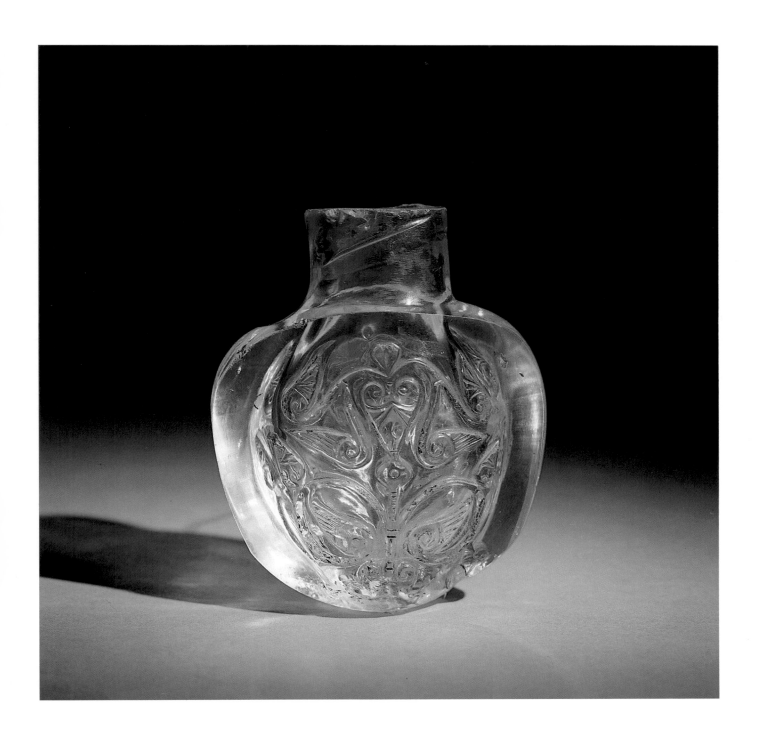

Bottle
Carved rock crystal
Egypt, early eleventh century AD
Height 17 cm LNS 3 HS

61

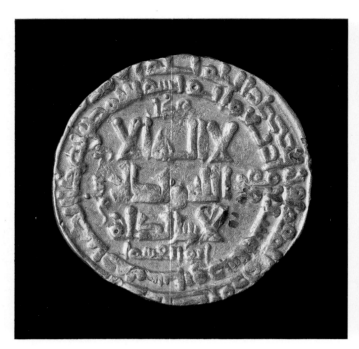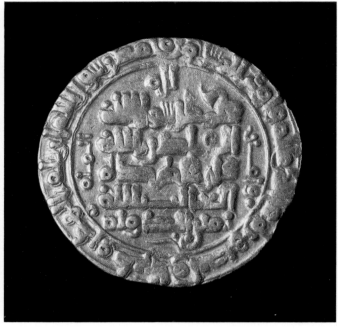

Dīnār
Gold
Iran, Nīsābūr, dated 407 AH/AD 1016–17
Diameter 2.3 cm LNS 26 N

INSCRIPTION ON OBVERSE CENTRE

عدل	*Justice*
لا اله الا الله وحده	*There is no God but God alone*
لا شريك له	*He has no associate*
أبو القاسم	*Abū'l-Qāsim*

ON LEFT DOWNWARD

رب سلم *Lord, Peace*

ON OBVERSE INNER MARGIN

بسم الله ضرب هذا الدينار بنيسابور سنة سبع وأربعمائة *In the name of God this dīnār was struck in Nīsābūr [in the] year seven and four hundred*

ON OBVERSE OUTER MARGIN
Chapter XXX verses 4 to 5 of the Qur'ān

ON REVERSE CENTRE

لله	*To God*
محمد رسول الله	*Muḥammad is the messenger of God*
القادر بالله	*al-Qādir billāh*
ولي عهده	*Recipient of his oath*
الغالب بالله	*al-Ghālib billāh*
يمين الدولة	*Right hand of the regime*

TO RIGHT AND LEFT

وامين / الملة *and Trustee of the religion*

ON MARGIN
Chapter X verse 33 of the Qur'ān

62

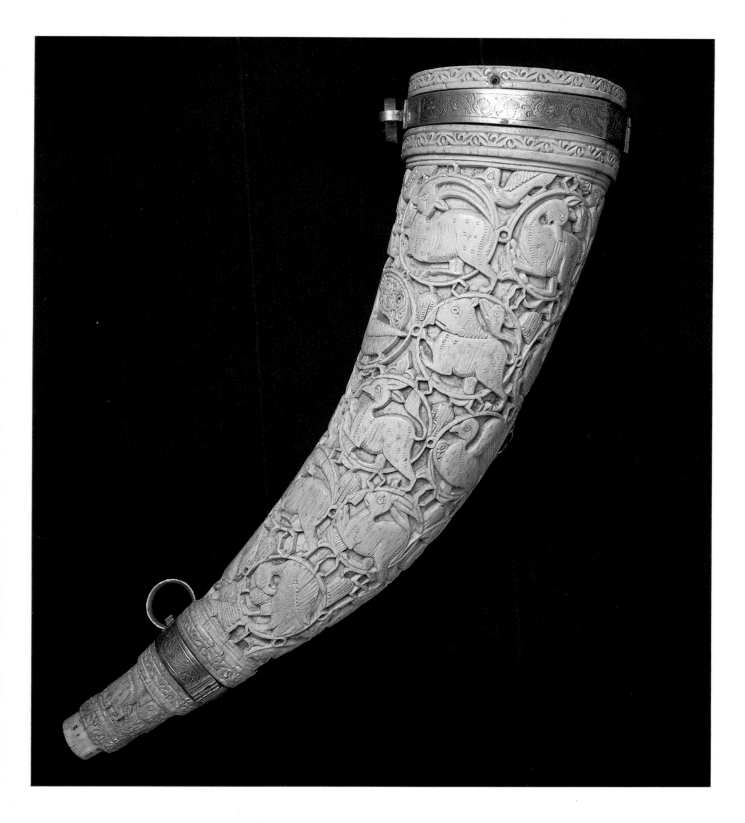

Hunting horn
Carved ivory
Italy, late eleventh–early twelfth century AD (fittings not of the period)
Greatest length 42.7 cm LNS 12 I

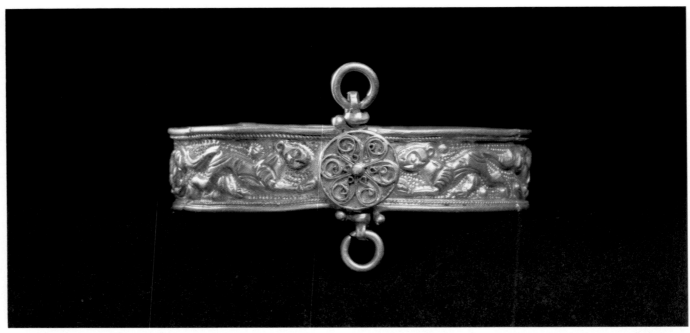

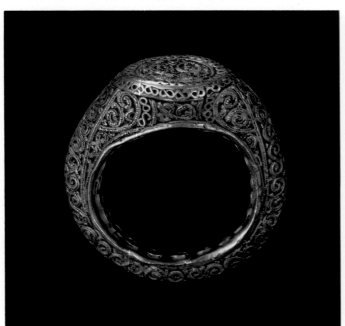

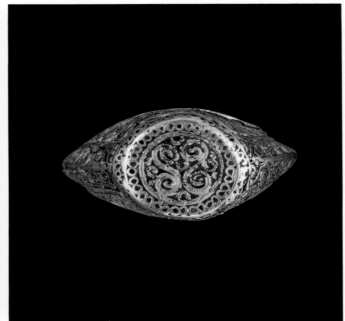

Bracelet
Gold, fabricated from sheet and wire, decorated with punches, shot, wire and *repoussé*
Greater Iran, twelfth–thirteenth century AD
Greatest diameter 6 cm LNS 31 J

Ring
Gold, fabricated from sheet and wire, decorated with wire and granulation
Greater Syria, eleventh century AD
Inner diameter 1.8 cm LNS 35 J

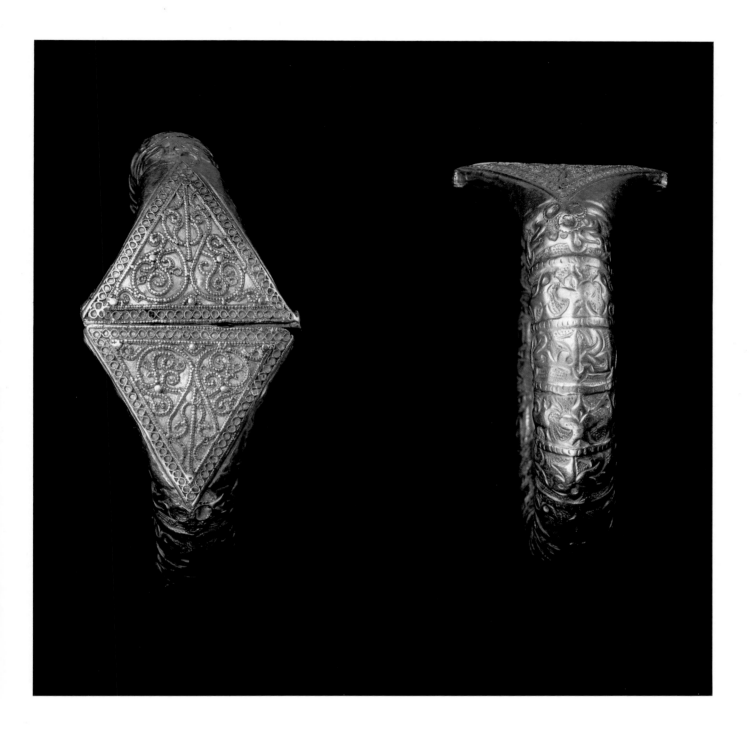

Pair of bracelets
Gold, fabricated from sheet, decorated with punches,
granulation, flat and twisted round wire, and *repoussé*
Greater Syria, eleventh century AD
Diameter 8 cm LNS 7 Jᵃᵇ

INSCRIBED ON EACH SHANK
بركة كاملة *Perfect blessing*

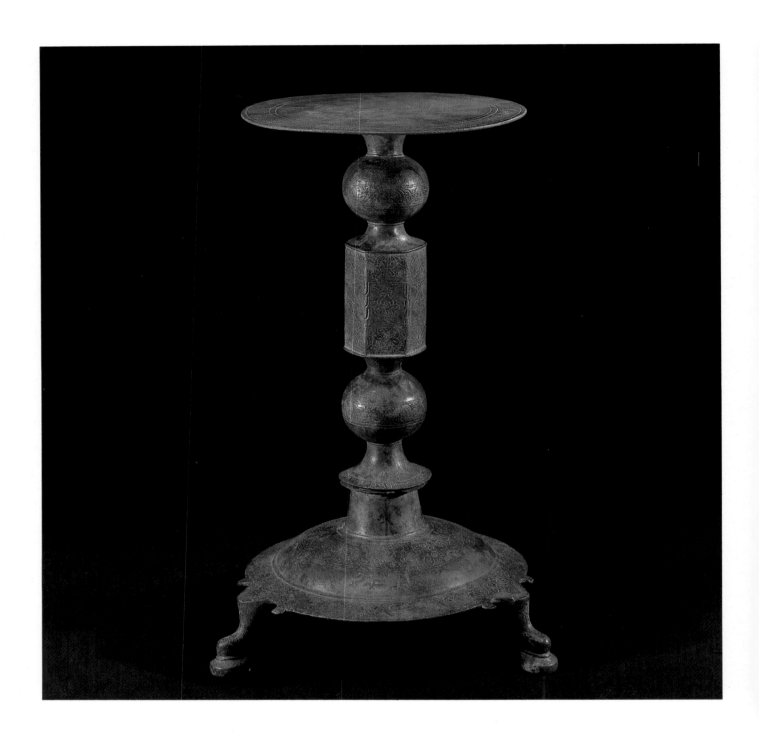

Lampstand
Bronze, cast and engraved
Egypt, eleventh century AD (tray not of the period)
Height 51 cm LNS 120 M

INSCRIBED ON DOMICAL AREA OF BASE THREE TIMES
بركة من *Blessing from [God]*

ON HEXAGONAL SHAFT AND UPPER PART OF DOMICAL AREA OF BASE
pseudo-Kufic inscriptions may be seen containing forms derived from the word
بركة *Blessing*

66

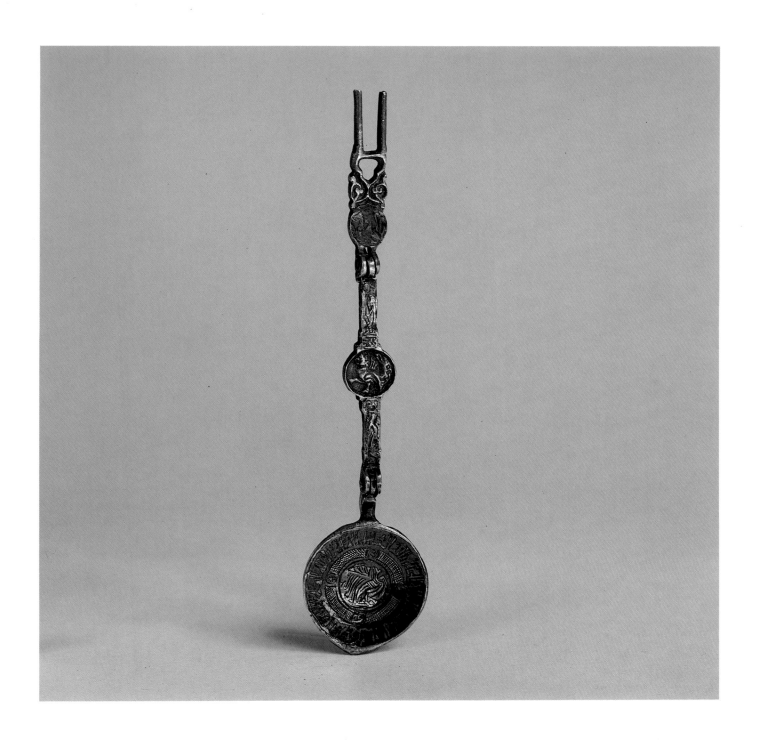

Folding spoon and fork
Silver, cast, engraved and inlaid with niello
Iran, twelfth century AD
Length 14.5 cm LNS 104 M

INSCRIBED

القوّة للّه الملك للّه الشكار [sic. for الشكر] للّه الكبرة للّه العزّة للّه (البّرة؟) للّه *Power is God's. Sovereignty is God's. Thanks is God's. Greatness is God's. Glory is God's. (Obedience?) is God's*

67

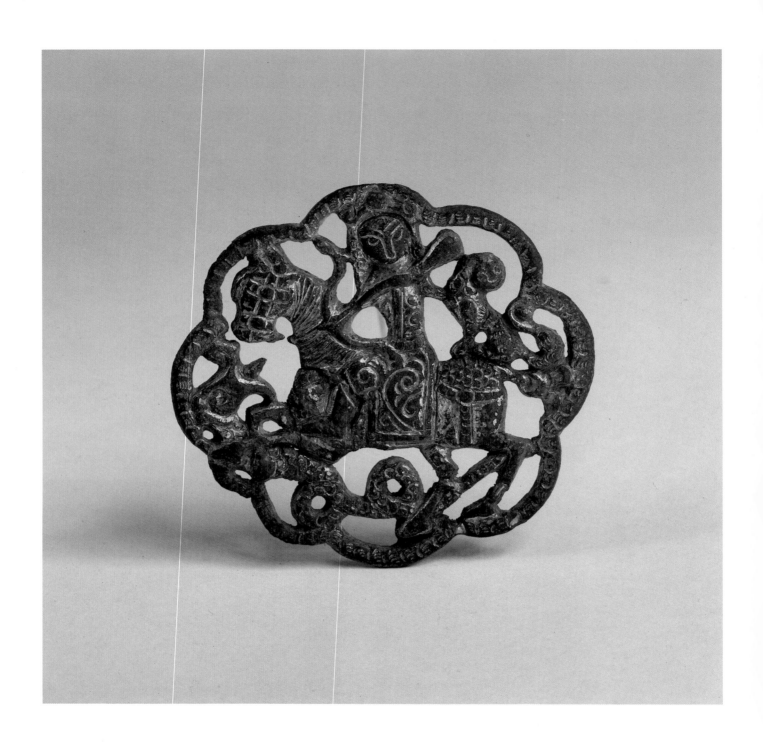

Plaque
Bronze, cast, engraved and gilded
Iran, twelfth–thirteenth century AD
Diameter 6 cm LNS 28 M

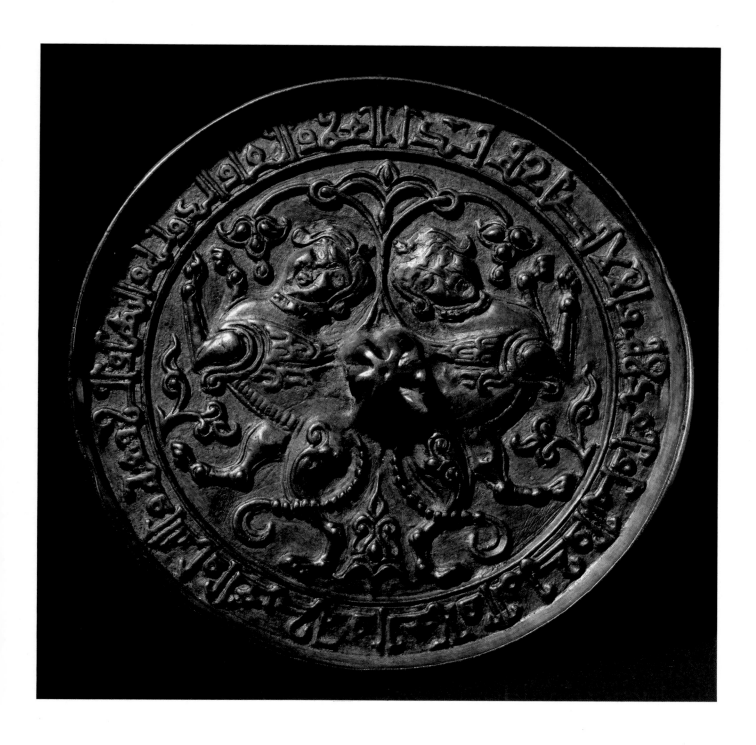

Mirror
Cast bronze
Eastern Anatolia or Northern Mesopotamia, early thirteenth century AD
Diameter 11.4 cm LNS 102 M

INSCRIBED

العزّ و البقا [ء] و الدولة و البها [ء] و الرفعة و الثنا [ء] و الغبطة و العلا [ء] و الملك و النّا [ء] و القدرة و الآلا [ء] لصاحبه ابدًا

Glory and continuance and good fortune and splendour and high position and praise and happiness and nobility and power and increase and potency and blessings to its owner forever

69

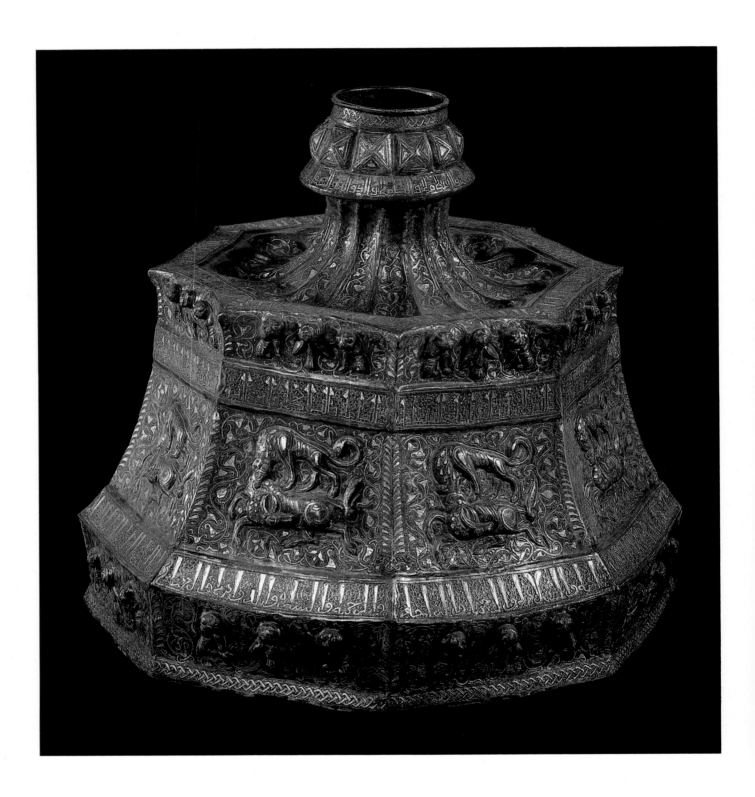

Candlestick
Bronze, raised from a single piece of sheet, engraved and inlaid with copper and silver
Iran, Khurasan, *c* 1200 AD
Height 31.7 cm LNS 81 M

Inscribed with a typical series of good wishes (for the owner)

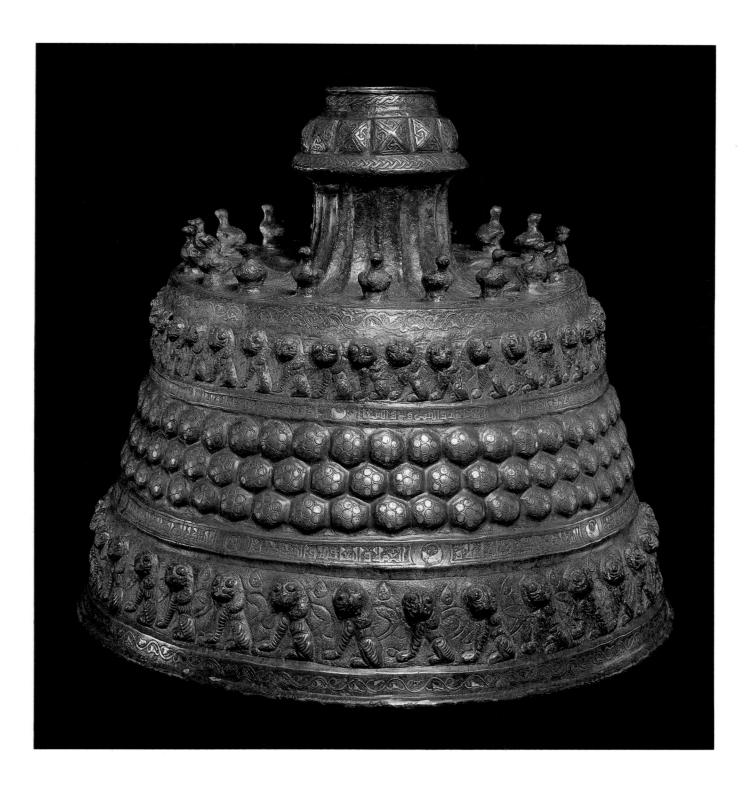

Candlestick
Bronze, raised from sheet (ducks made separately), engraved and inlaid with copper and silver
Iran, Khurasan, *c* 1200 AD
Height 31.7 cm LNS 82 M

Inscribed with a typical series of good wishes (for the owner)

71

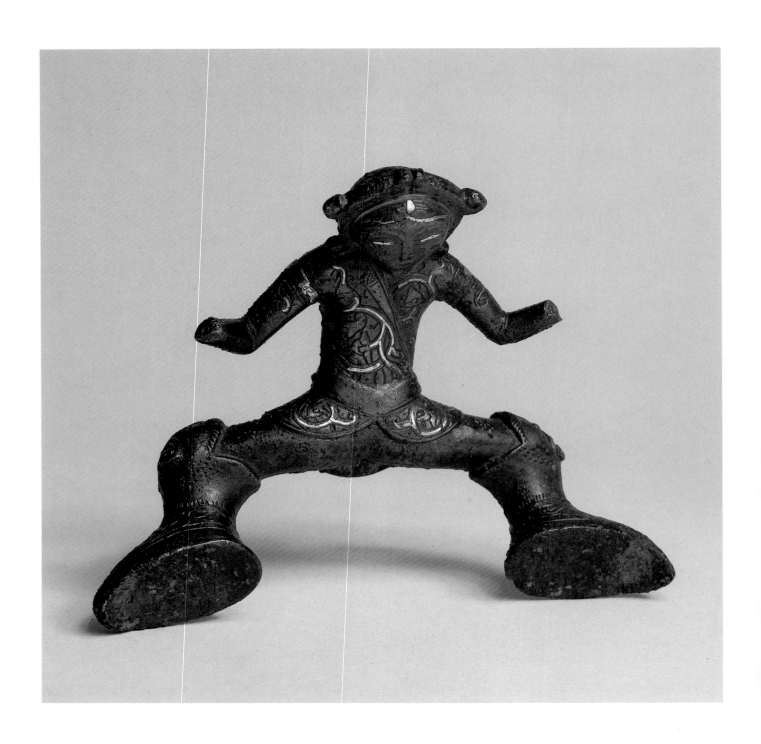

Handle
(probably from a cauldron)
Bronze, cast, engraved and inlaid with copper and silver
Iran, perhaps Nishapur, twelfth century AD
Greatest width 11 cm LNS 119 M

INSCRIBED ON UPPER ARMBANDS
اليمن و البركة *Happiness and blessing*

72

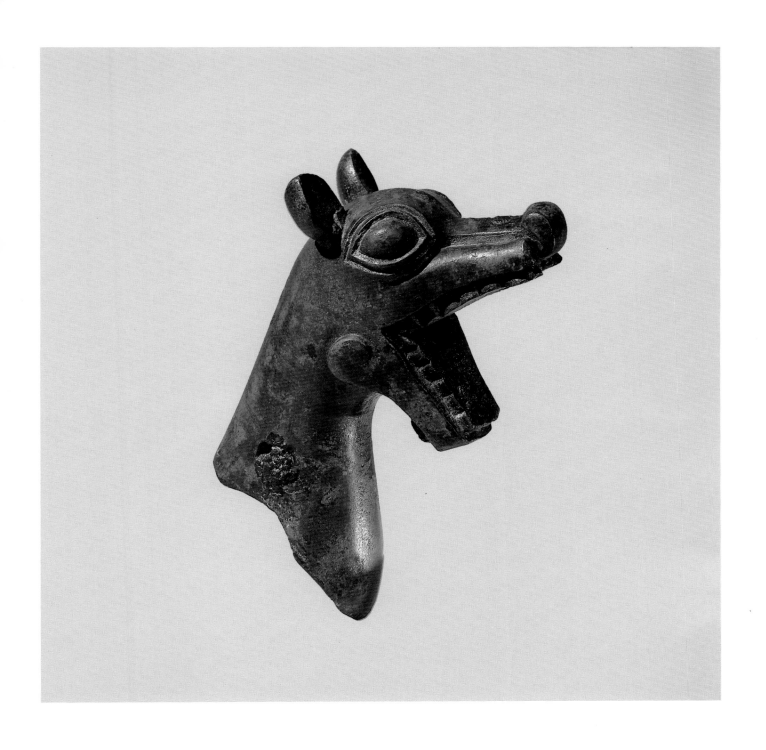

Spout
Cast bronze
Eastern Anatolia or Northern Mesopotamia, early thirteenth century AD
Greatest height 12 cm LNS 129 M

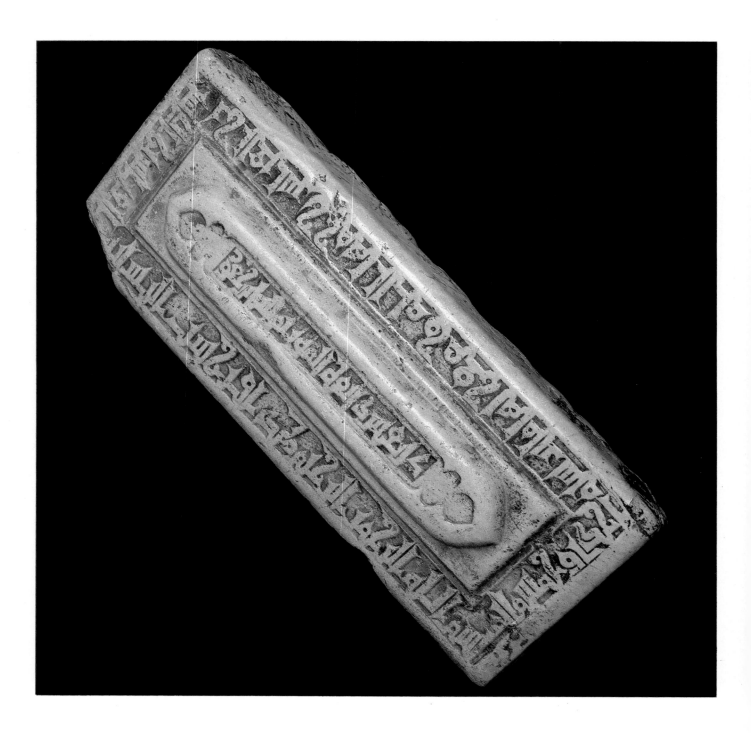

Tombstone
Carved marble
Egypt, dated 501 AH/AD 1107–1108
Length 62 cm LNS 16 S

INSCRIBED ON CENTRE
كل نفس ذائقة الموت ثم لله ترجعون *Death comes to everyone, and verily, to God we must return*

AROUND PERIMETER
بسم الله الرحمن الرحيم هذا قبر ست النساء بن[ـت] [broken] / العباس بن الحسن
بن العباس رحمها وغفر لها ماتت سنة / احدى وخمسمائة

In the name of God, the Merciful, the Compassionate. This is the tomb of the
young lady, daughter of al-ʿAbbās, son of al-Ḥasan, son of al-ʿAbbās. He [God]
was merciful to her and pardoned her. She died [in the] year one and five hundred

74

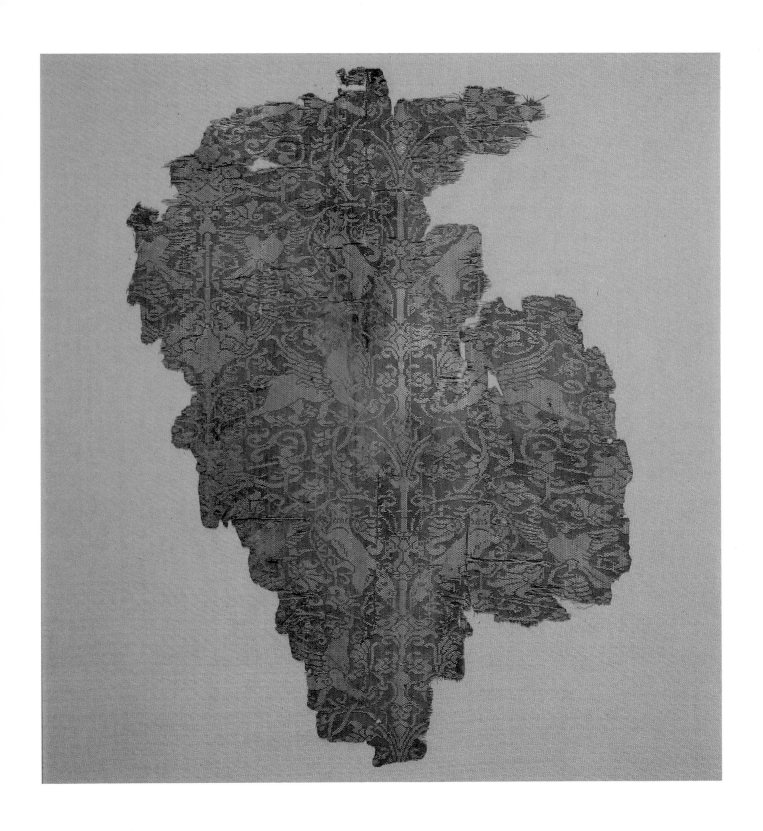

Textile fragment
Silk, a compound weave
Syria, thirteenth century AD
Height 33 cm LNS 9 T

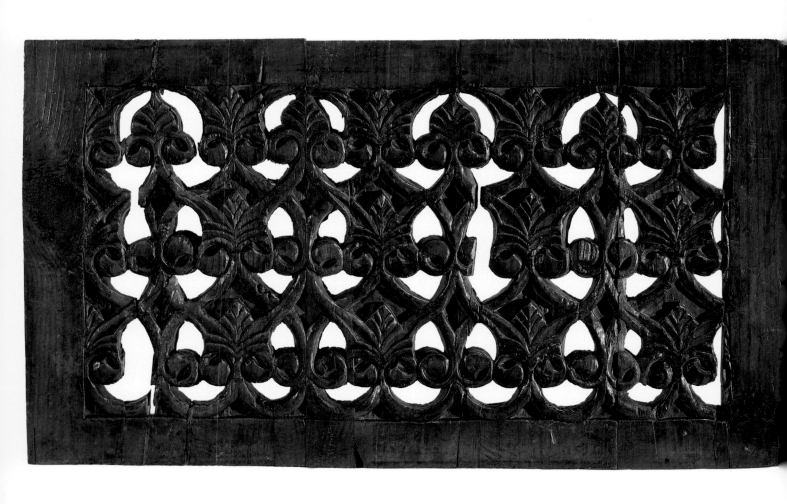

Panel
(probably from a *tābūt*)
Carved wood
Egypt, thirteenth century AD
Width 52 cm LNS 24 W

Late Medieval Islamic Period

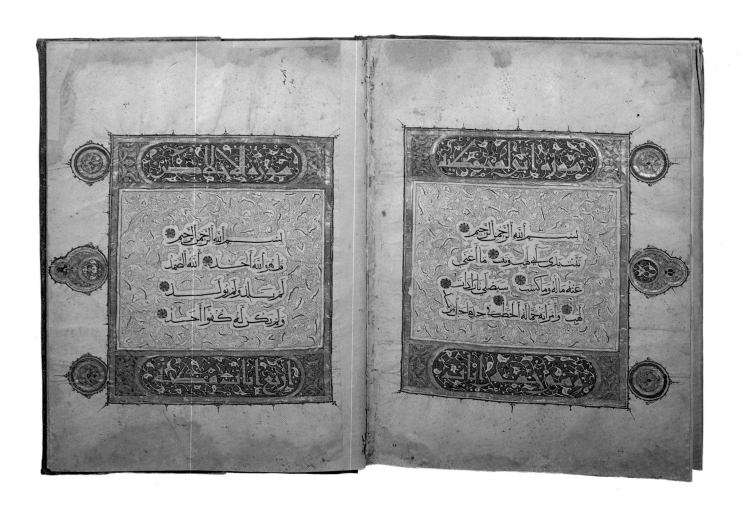

Complete manuscript of the Qur'ān
Ink, colours and gold on paper
Egypt, dated 25 Ramaḍān 746/19 January 1346 AD
Height 51.5 cm LNS 47 MS

COLOPHON INSCRIPTION

كتب هذه الختمة الشريفة المعظّمة العبد الفقير الذليل الحقير المقرّ بالتقصير الراجى عفو ربّه
السميع البصير اسنبغابن طرلّى السيفي ارغون شاه استادار الملكى ال[obliterated] (تمت؟) فى
الخامس والعشرين من شهر رمضان المعظّم سنة ست واربعين وسبع مائة أحسن الله عاقبتها
وغفر له ولوالديه وللجميع المسلمين آمين برحمتك يأرحم [يأرحم] الراحمين ... [صلى] الله
[على] سيّدنا محمد واله وصحبه وسلّم

*The poor slave [of God], the abject, the despicable, the confessor of his
shortcomings, in hope of the pardon of his Lord, the All-Hearing, the All-Seeing,
Asanbughā son of (Ṭuralāy?) al-Sayfī Arghūn Shāh, Ustādār (Major-Domo)
in the service of the King [obliterated] wrote this revered, exalted complete copy
of the Qur'ān. [It was completed] on the fifth and the twentieth of the venerated
month of Ramaḍān [of the] year six and forty and seven-hundred. May God
make its outcome good and grant him [the calligrapher] and his parents and all
the Muslims pardon. Amen. By Your mercy, O Most Merciful God's
blessing and peace be upon our master Muḥammad and upon his family and his
Companions*

78

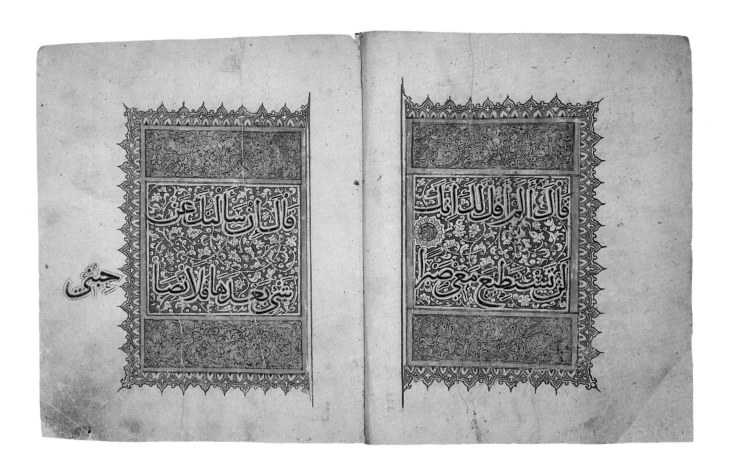

One part of a six-part manuscript of the Qur'ān
Ink, colours and gold on paper
Iran or Iraq, fourteenth century AD
Height 19.5 cm LNS 44 MS

Contains the section beginning with verse 75 of Chapter XVIII and continuing to verse 56 of Chapter XXIII,
with interlinear Persian translation

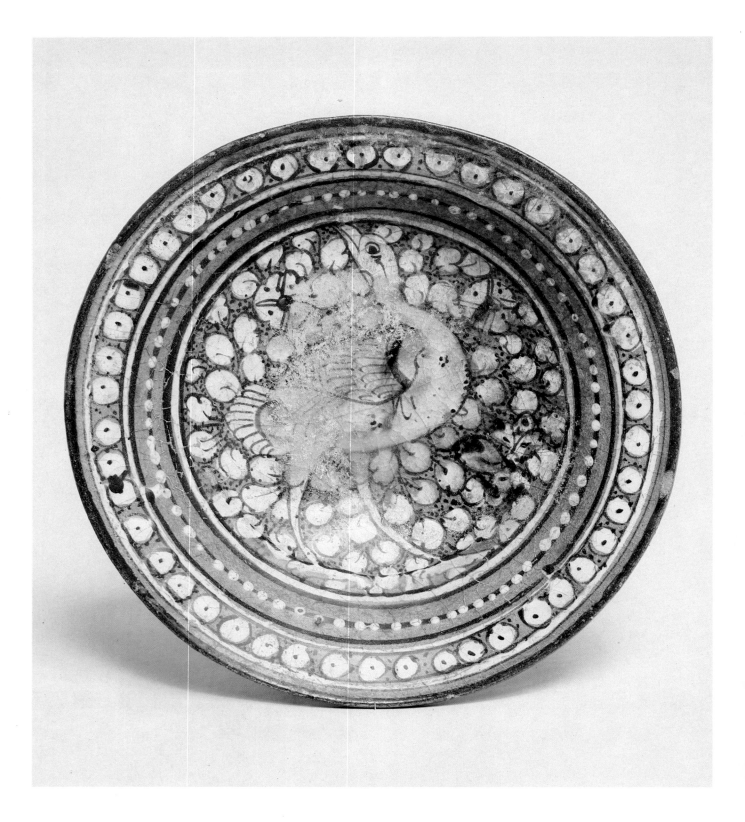

Dish
Composite body, grey engobe, underglaze slip and stain painted
Iran, first half fourteenth century AD
Diameter 30.5 cm LNS 162 C

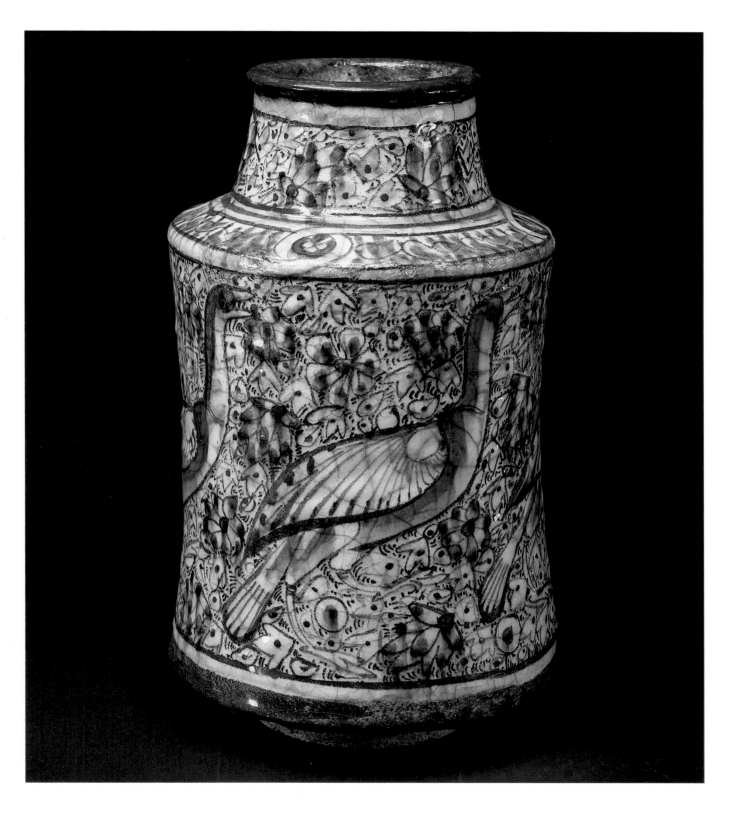

Albarello
Composite body, underglaze frit and stain painted
Syria, fourteenth century AD
Height 30 cm LNS 187 C

81

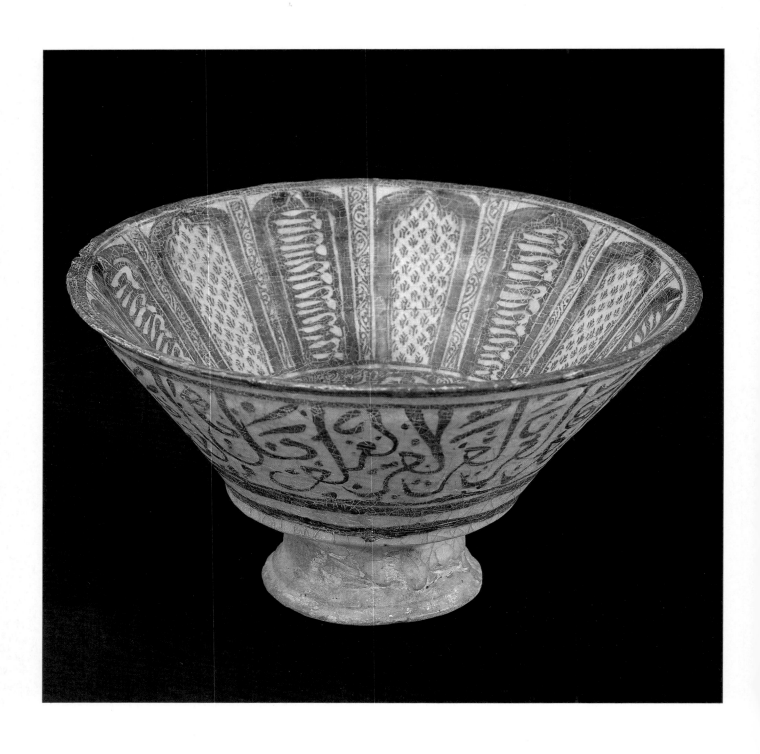

Bowl
Composite body, underglaze painted
Syria, fourteenth century AD
Diameter 30.5 cm LNS 122 C

82

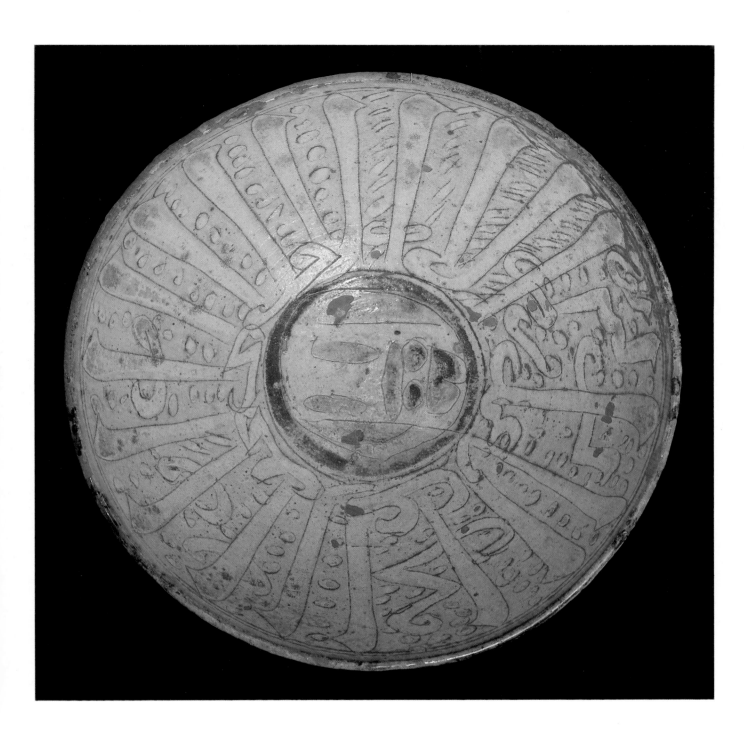

Bowl
Earthenware, white engobe, incised, underglaze slip and inglaze painted
Egypt, fourteenth century AD
Diameter 38 cm LNS 125 C

83

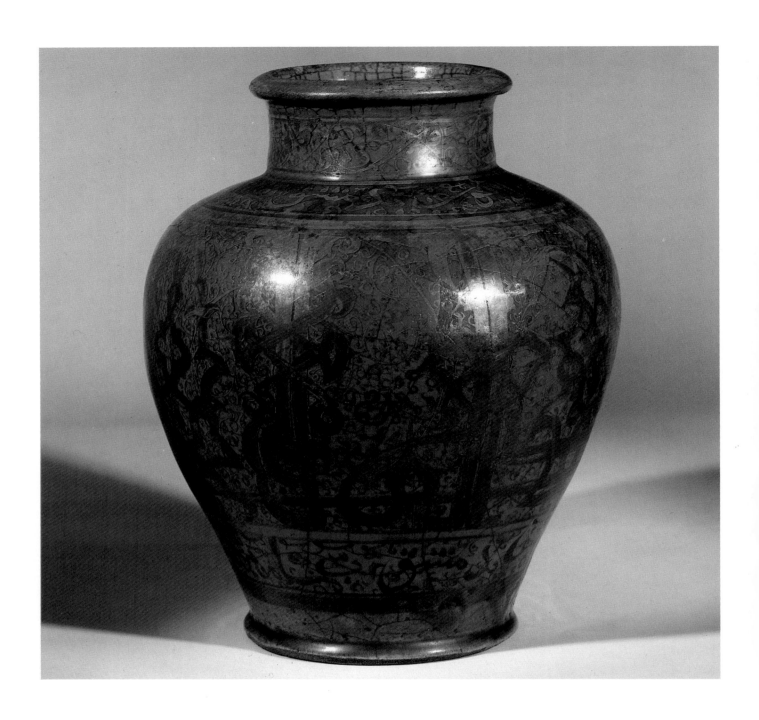

Vase
Composite body, glazed and lustre painted
Syria, Damascus, thirteenth century AD
Height 29 cm LNS 188 c

INSCRIBED ABOVE
مما عمل برسم اسد الاسكندرانى عمل يوسف بدمشق نقش *Made for Asad al-Iskandarānī, the work of Yūsuf in Damascus, naqsh*

BELOW
مما عمل برسم اسد الاسكندرانى عمل يوسف بدمشق رب سلم برحمتك *Made for Asad al-Iskandarānī, the work of Yūsuf in Damascus, oh Lord, in Your mercy grant salvation*

84

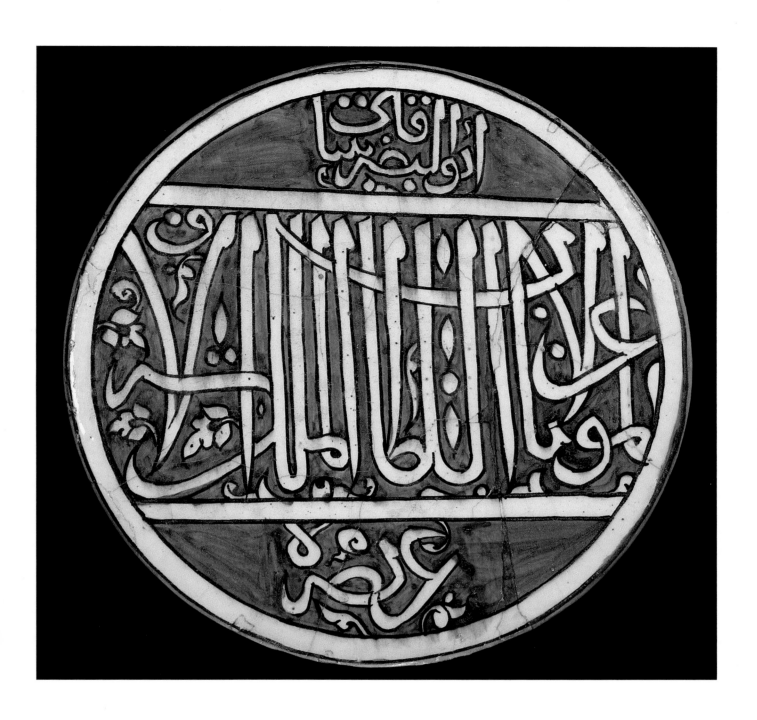

Tile
Composite body, underglaze painted
Egypt, late fifteenth century AD
Diameter 29 cm LNS 190 C

INSCRIBED

Glory to our Master, the Sultan al-Malik al-Ashraf Abū 'l-Naṣir Qāytbāy, may his victory be glorious عز لمولانا السلطان الملك الاشرف ابو النصر قايتباى عز نصرة

85

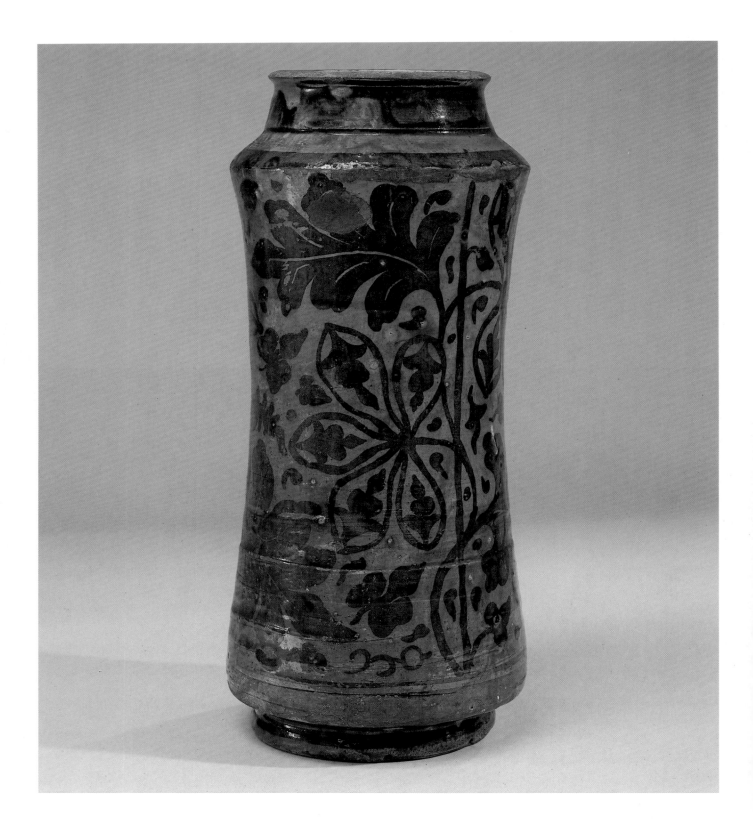

Albarello
Earthenware, glazed and lustre painted
Spain, fifteenth century AD
Height 30.5 cm LNS 91 C

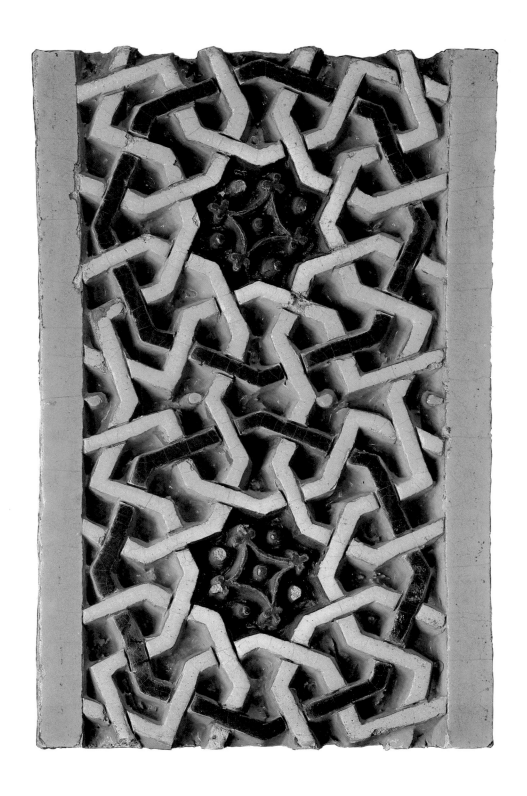

Tile
Composite body, carved and glaze painted
Greater Iran, second half fourteenth century AD
Length 32.5 cm LNS 146 C

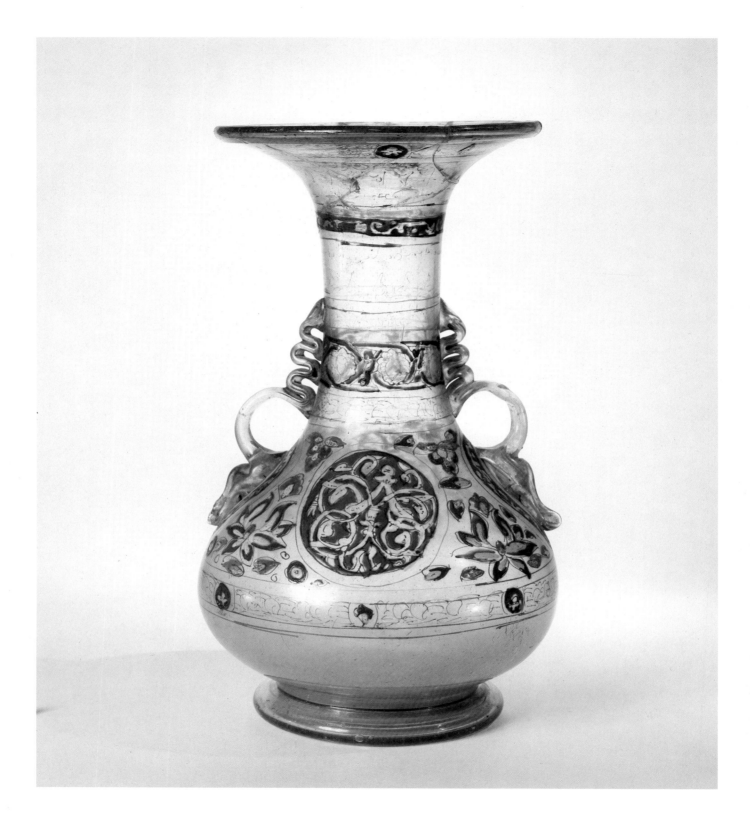

Bottle
Glass, free blown and tooled, with plastically applied handles, enamelled
Syria or Egypt, first half fourteenth century AD
Height 31 cm LNS 6 G

Stand
Ivory (originally inlaid), on modern base
Egypt or Syria, fourteenth century AD
43 cm square LNS 4 I

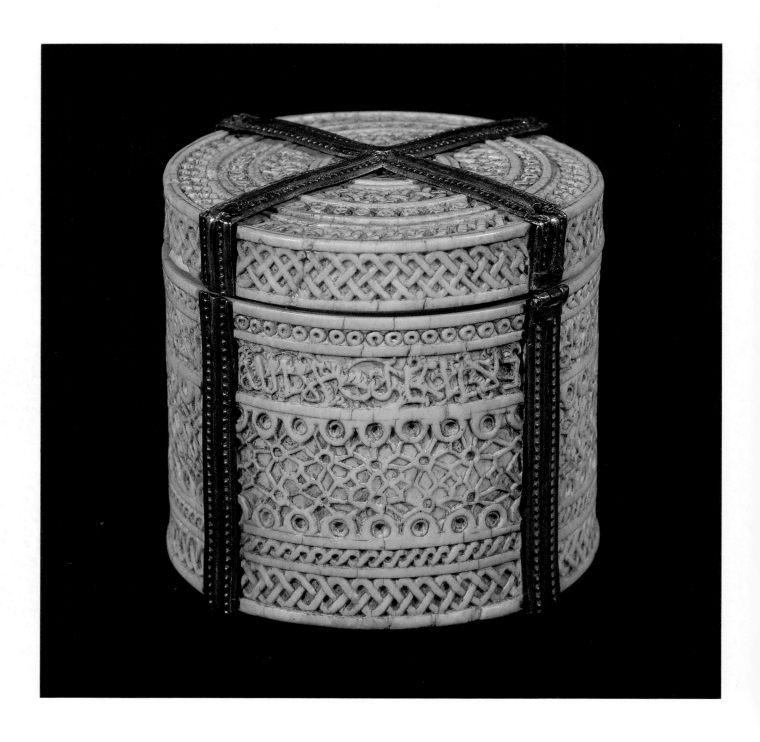

Pyxis
Ivory, turned and carved
Spain, probably Granada, fourteenth century AD
Diameter 8.5 cm LNS 7 I

INSCRIBED
ولا غالب الا الله *There is no victor but God*

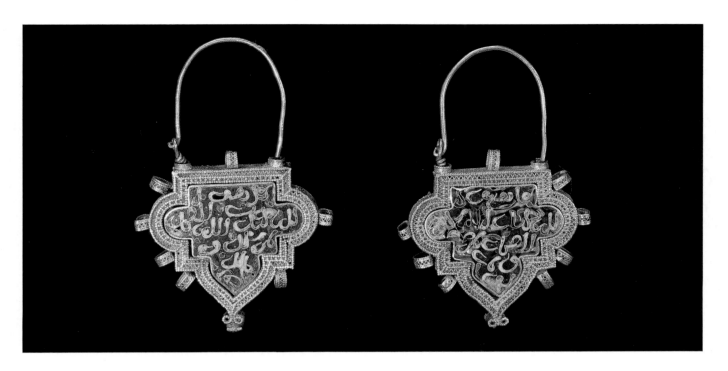

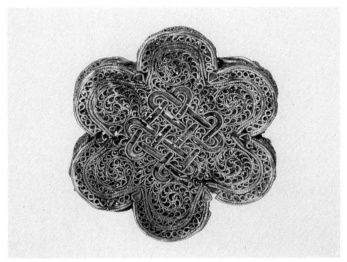
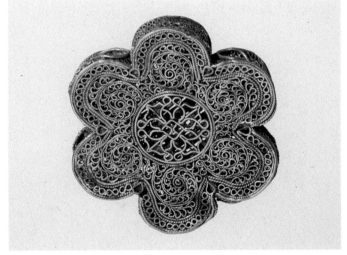

Pair of earrings
Gold, fabricated from sheet, wire and grains, set with *cloisonné* enamels; originally outlined with strung
pearls and/or stones
Probably Spain, twelfth century AD
Height with earwires 4.8 and 4.65 cm LNS 30 J^{ab}

Each of the four cloisonné *enamels is inscribed with the first two verses of Chapter CXII of the Qur'ān*

Rosette
(with two pairs of holes for stringing)
Gold, fabricated from wire and strips of sheet
Syria or Egypt, last half fourteenth century AD
Diameter 4.2 cm LNS 21 J

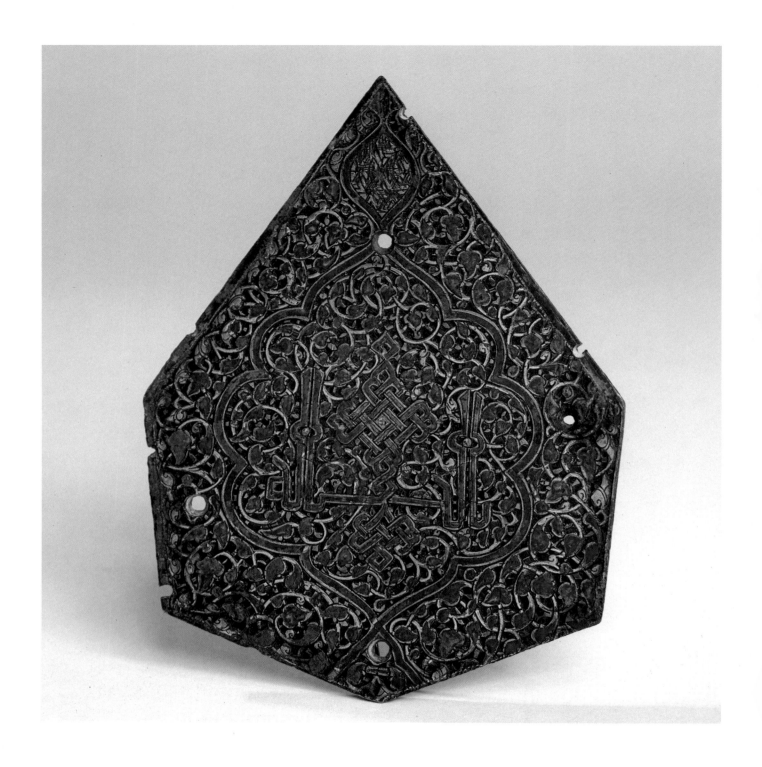

Polygon from a star-pattern
(probably originally decorating a door)
Bronze, cast, engraved and inlaid with copper, silver and gold
Iran, first half fourteenth century AD
Greatest dimension 13 cm LNS 5 M

INSCRIBED
الله *God*

92

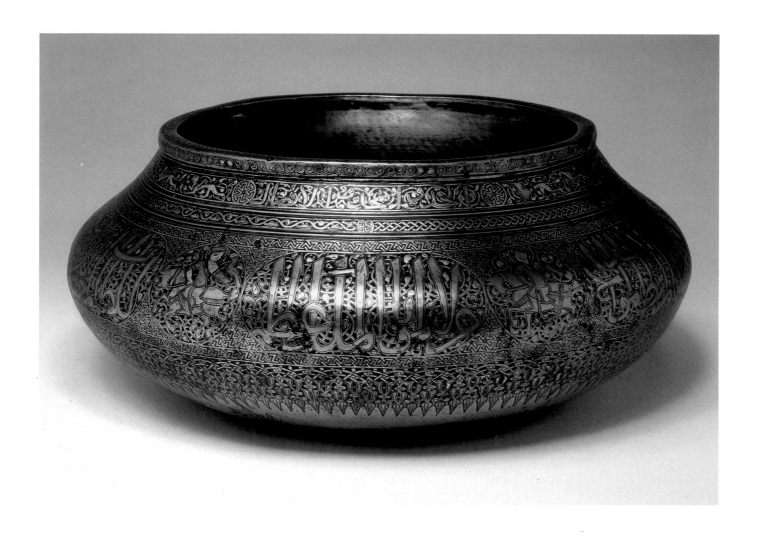

Bowl
Bronze, hammered, engraved and inlaid with silver and gold
Iran, probably Fars, first quarter fourteenth century AD
Diameter 28 cm LNS 116 M

العزّ و الاقبال [و] الالنعم [sic. for النعمة] و / الجدّ و المجد و الافضال / و الكرم و الالعلم
[sic. for العلم] و الحلم

*Glory and prosperity and good fortune and worldly advancement and dignity and
abundance and generosity and knowledge and forbearance*

عزّ لمولانا الملك [الا] عظم ا / سلطان [ا] لمعظّم [ما] لك [ر] قاب الا / مم السلطان
اسلاطين [sic. for سلاطين] سلطان سلاطين العر / ب [و] و العجم العالم العاد / ل المظفّر المؤيّد المكرّم
لا (؟) / المجاهد المرابط المؤيّد ا /

*Glory to our lord the [grea]test king, the august Sulṭān, holder of the necks of the
nations, master of the sultans of the Arabs and the Persians, the wise, the just,
the victorious, the aided [by God] the honoured the warrior [of the Faith],
the defender of the frontiers, the aided [by God]*

93

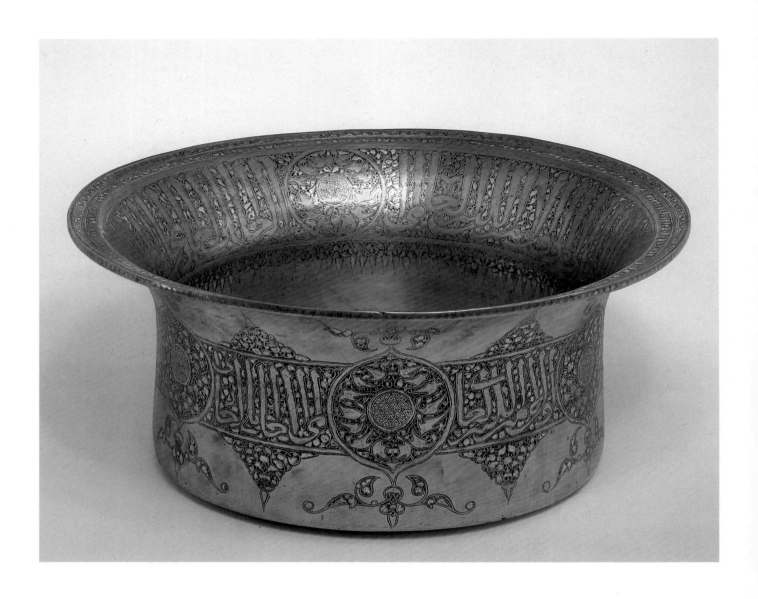

Basin
Bronze, raised from sheet, engraved and inlaid with silver
Egypt or Syria, first half fourteenth century AD
Diameter 49 cm LNS 110 M

INSCRIBED IN SMALL CIRCLE ON INTERIOR OF BASE

المقرّ العالى المولوى الاميرى العالمى العاملى الغازى المجاهدى المرابطى الناصرى

*The High Excellency, servant of the wise, the effective, the extender of the realm,
the warrior, the defender of the frontiers, the Prince al-Nāṣir*

ON INTERIOR OF RIM

المقرّ العالى المولوى الاميرى الكبير[ى] العالمى ا / العاملى الغازى المجاهد[ى] المرابطى
المؤيّدى الـ / النصيرى المديرى المسيرى الظهيرى النظامى الملكى الناصرى

*The High Excellency, servant of the wise, the effective, the extender of the realm,
the warrior, the defender of the frontiers, the aided [by God], the , the
defender, the director, the marcher, the partisan, the organiser, the Great Prince,
the King al-Nāṣir*

ON EXTERIOR

المقرّ العالى المو / لوى الامير[ى] الكبير[ى] لعا / لى العاملى الغازى المجاهدى
المرا [بـ] طى

*The High Excellency, servant of the wise, the effective, the extender of the realm,
the warrior, the defender of the frontiers, the Great Prince*

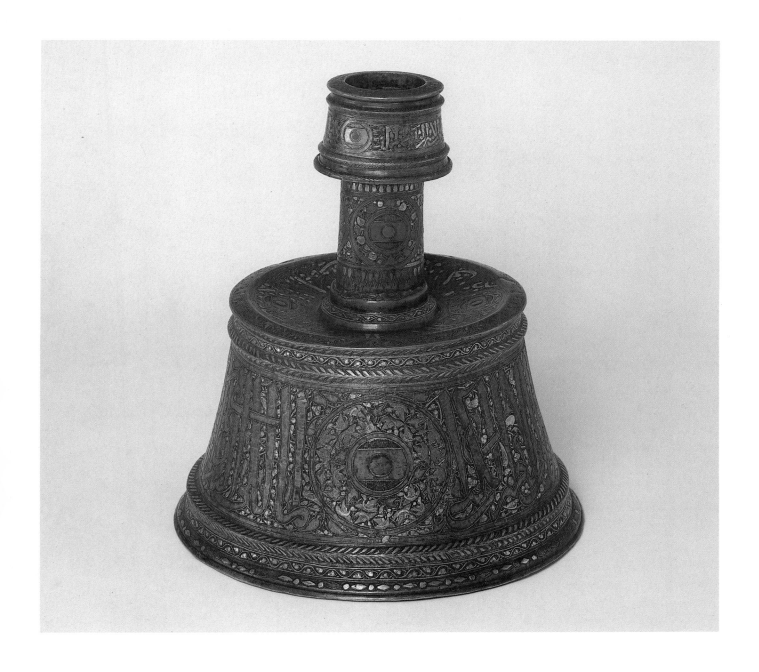

Candlestick
Bronze, raised from sheet, engraved and inlaid with copper and silver
Egypt or Syria, first half fourteenth century AD
Height 39.4 cm LNS 99 M

INSCRIBED AROUND SOCKET

المقرّ العالى المولوى الا / ميرى الكبير البدرى بدر الدين / يلبو القرمانى الناصرى

The high noble lord, servant of the Great Prince, former mamlūk of Badr al-Dīn, Badr al-Dīn Yalbū of Qaramān, mamlūk of al-Nāṣir

AROUND THE PAN AND THE BASE
(complete on each, except that the yā' of al-Badrī is missing on pan)

مما عمل برسم المقرّ العالى المولوى الاميرى الكبيرى المالكى البدرى بدر الدين يلبو القرمانى الملكى الناصرى

From among that which was made for the high noble lord, servant of the Great Prince, the Possessor, former mamlūk of Badr al-Dīn, Badr al-Dīn Yalbū of Qaramān, mamlūk of the King al-Nāṣir

95

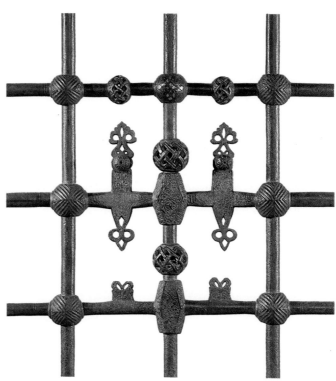

INSCRIBED ON CROSSBAR NEAR CENTRE

برسم المقرّ الاشرف العالى السيفى ازدمر / ملك الامراء ... أعزّ الله / انصاره

By order of the most noble high lord the Sayfī [originally belonging to Sulṭān Sayf al-Dīn Barqūq] Uzdamur, the Governor-General . . ., may God glorify his supporters

ON LOZENGE SHAPE, BELOW INSCRIBED CROSSBAR

عمل العبد الفقير / الى الله المتعال / ... غفر الله لهم

Work of the poor slave of God the Most Exalted . . . may God pardon them

Window-grille
Iron, wrought, engraved, hatched and overlaid with gold
Syria, *c* 893 AH/AD 1488
Height 280 cm LNS 128 M

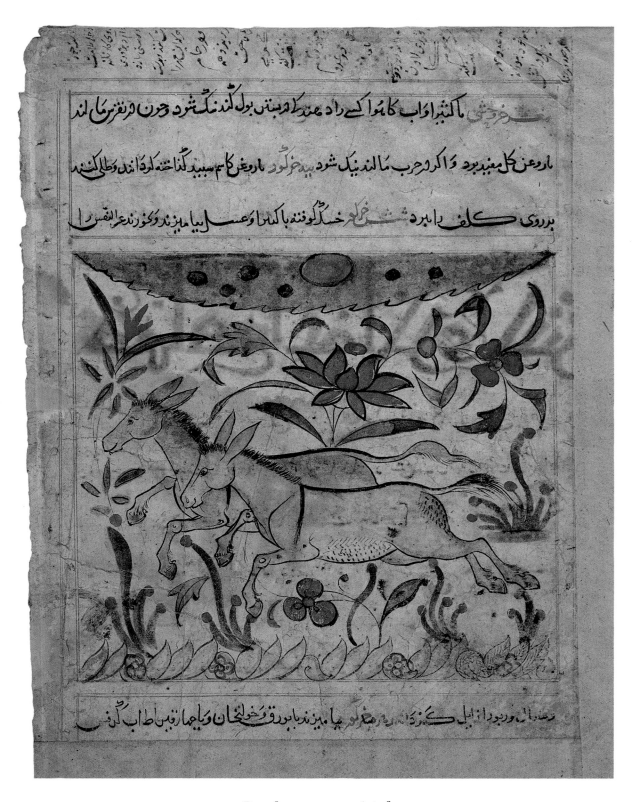

Page from a manuscript of
'Manāfi' al-Ḥayawān' by Abū Sa'id 'Ubayd Allāh ibn Bakhtīshū'
Ink and colours on paper
Iran, early fourteenth century AD
Height 26 cm LNS 59 MS

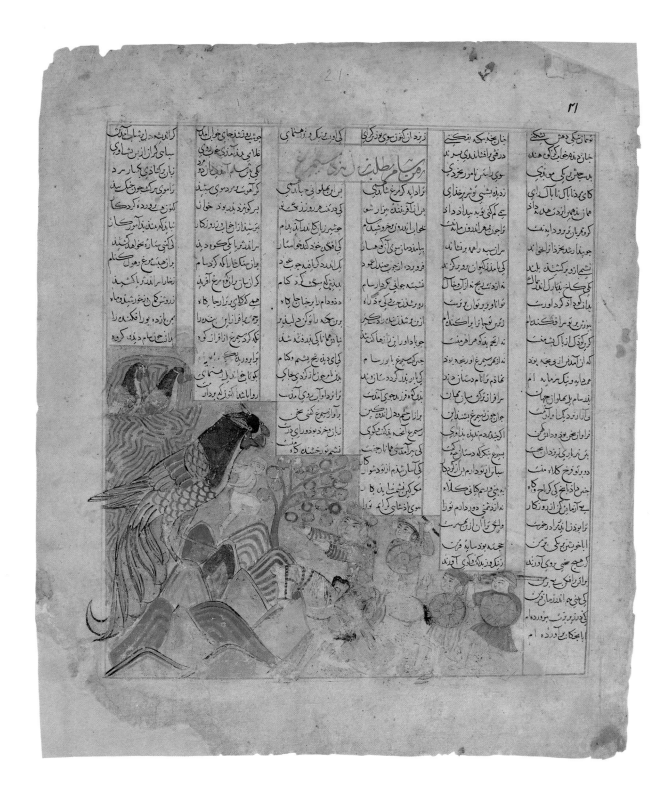

Zal discovered by his father, Sam
Miniature from a manuscript of the *Shah-nameh* by Ferdowsi
Ink, colours and gold on paper
Iran, Shiraz, first half fourteenth century AD
Height 30 cm LNS 36 MS

98

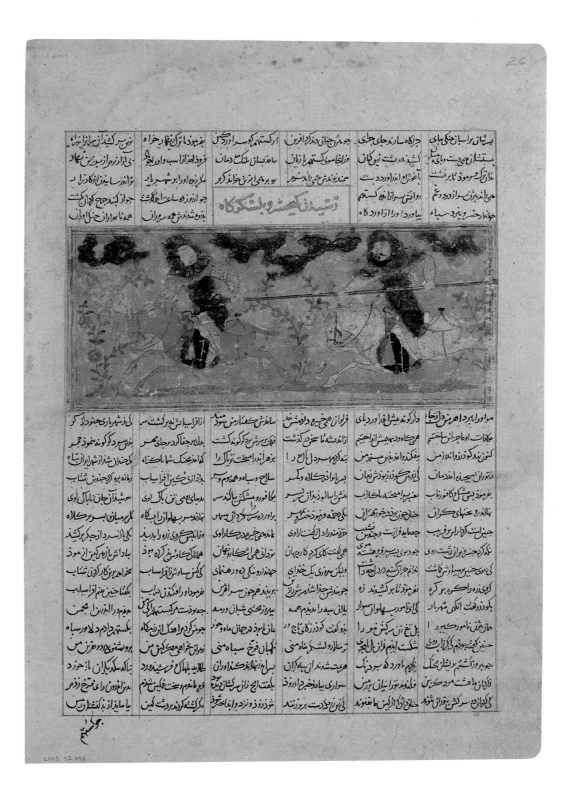

Kay Khosrow in combat
Miniature from a manuscript of the *Shah-nameh* by Ferdowsi
Ink, colours and gold on paper
Iran, early fourteenth century AD
Height 30.5 cm LNS 32 MS

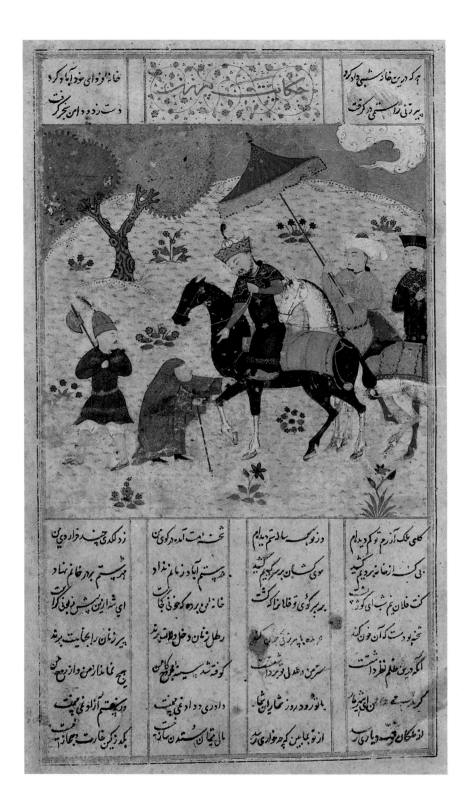

Sultan Sanjar and the old woman
Miniature from a manuscript of the *Khamseh* by Nizami
Ink, colours and gold on paper
Iran, Shiraz, dated 893 AH/AD 1487–88
Height of page 29.6 cm LNS 28 MS

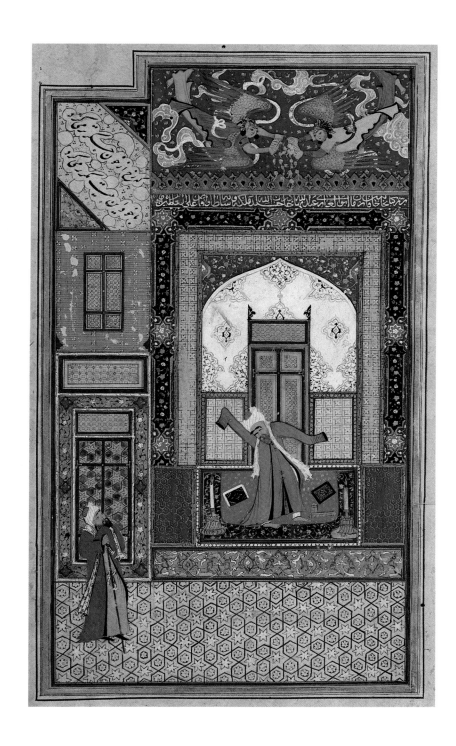

Miniature from a manuscript of the 'Subḥat al-Abrār' by Jāmī
Ink, colours and gold on paper
Iran, Bukhara, second quarter sixteenth century and in a manuscript dated 902 AH/AD 1496–97
Height of page 27.9 cm LNS 16 MS

INSCRIBED

برسم کتابخانه خاقان ... ابو الغازی عبدالله بهادرخان خلد الله ملکه وسلطانه ... *By the order of the Kitābkhāneh of Khāqān Abū al-Ghāzī 'Abd Allāh*
Behādur Khān, may God make his rule and power eternal

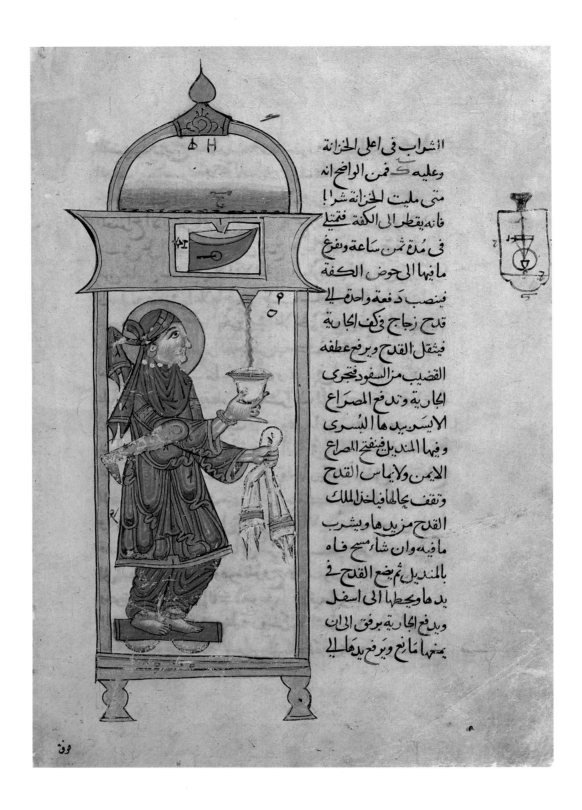

الشراب في أعلى الخزانة
وعليه ... فمن الواضح انه
متى مليت الخزانة شربا
فانه يقطر الى الكفة فتمتلئ
في مدة ثمن ساعة وفرغ
ما فيها الى الحوض الكفة
فينصب دفعة واحدة الى
قدح زجاج في كف الجارية
فينقل القدح ويرفع عطفه
القضيب من السفود فتجري
الجارية وتدفع المصراع
الايسر بيدها اليسرى
وفيها المنديل فينفتح المصراع
الايمن ولا يباس القدح
وتقف بحالها فيأخذ الملك
القدح من يديها ويشرب
ما فيه وان شاء مسح فاه
بالمنديل ثم يضع القدح في
يدها ويحطها الى اسفل
ويدفع الجارية ويرفق الى ان
يضعها اما رفع ويرفع يد عالي لي

Automaton of a girl offering wine to the king
Miniature from a manuscript of *Kitāb fī maʿrifat al-ḥiyal al-handasiya* by al-Jazarī
Ink, colours and gold on paper
Egypt, 1315 AD
Height 31.2 cm LNS 17 MS

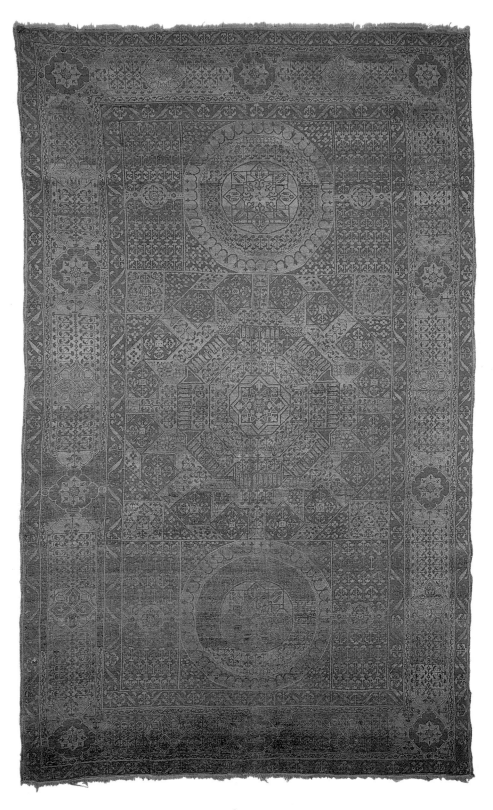

Carpet
Wool warp, weft and pile
Egypt, last quarter fifteenth century AD
Length 375.5 cm LNS 14 R

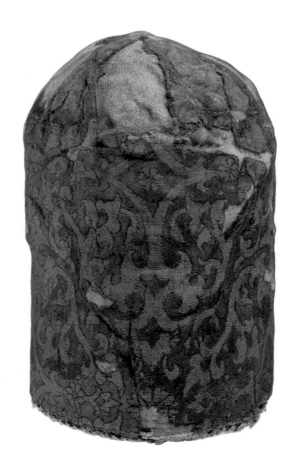

Cap
Silk
Egypt or Syria, fourteenth–fifteenth century AD
Diameter 20 cm LNS 95 T

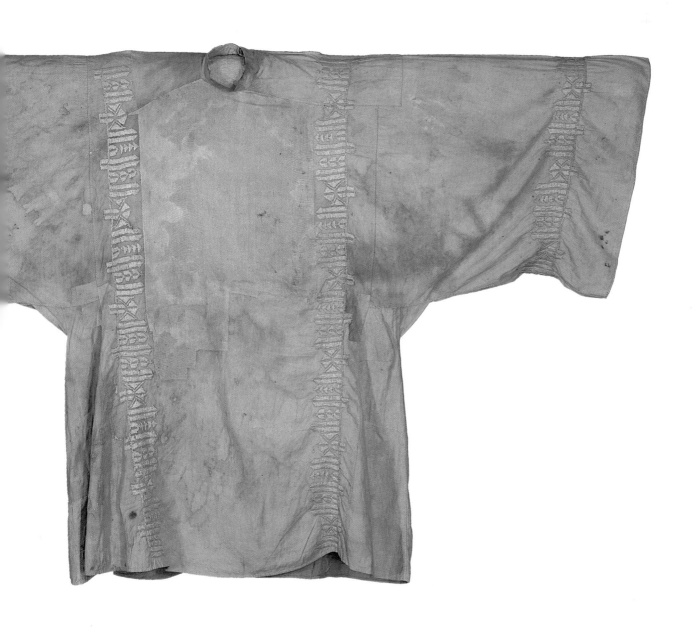

Garment
Linen with silk embroidery
Egypt, early sixteenth century AD
Length 132 cm LNS 57 T

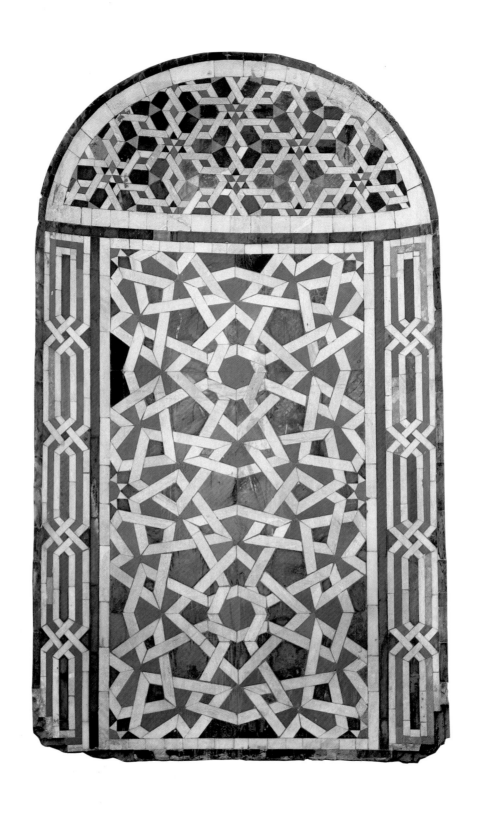

Niche
Marble mosaic
Egypt, first quarter fifteenth century AD
Height 150 cm LNS 24 S

106

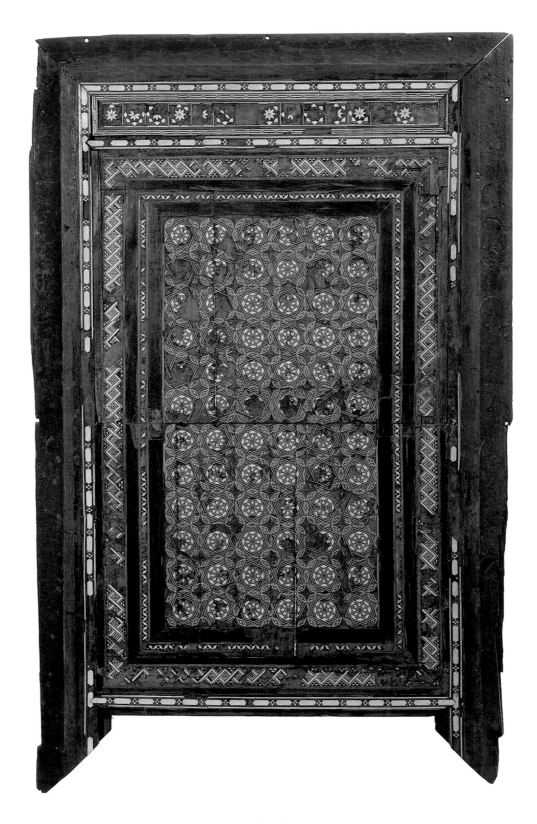

Panel
Wood, mitred, rabbeted and mortised, overlaid with marquetry of ivory and contrasting woods
Egypt, *c* third quarter fourteenth century AD
Height 100 cm LNS 12 W

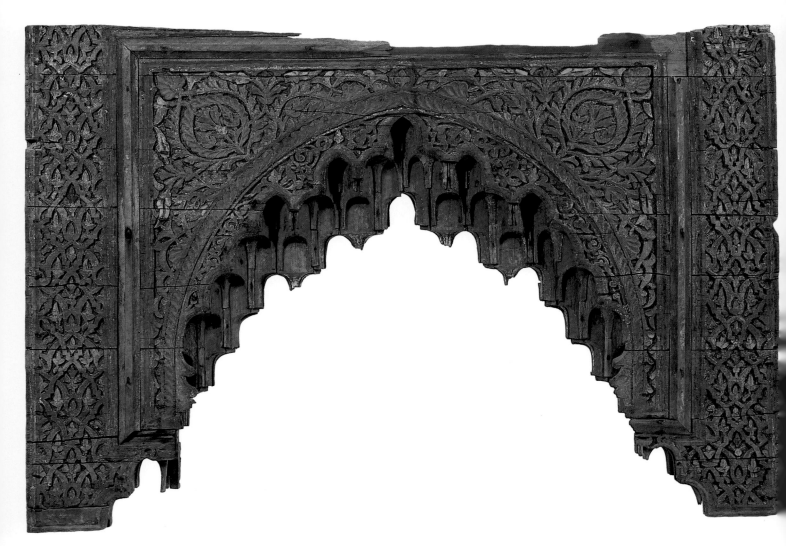

Arch
Wood, worked in a variety of joinery techniques, carved and painted
Morocco, fourteenth century AD
Height 100 cm LNS 46 W

Pair of doors
Wood, mitred, rabbeted, mortised, carved and painted
Morocco, Fez, fourteenth century AD
Height 443 cm LNS 52 Wab

INSCRIBED ON PANEL a FRONT
Cursive inscription around perimeter, verse 255 of Chapter II of the Qur'ān

BACK
Kufic inscription around perimeter, repetitions of
السعد والتوفيق [و] نعم الرفيق *Good fortune and success [and] good friends*

ON PANEL b FRONT
Cursive inscription around perimeter, verses 285 and 286 of Chapter II of the Qur'ān

BACK
Kufic inscription around perimeter, same as that on Panel a

ON PANELS a AND b, FRONT AND BACK OF EACH
Kufic inscription around perimeter of small door on lower half, repetitions of
والله خير حفظا و هو ارحم الراحمين *And God is the Best of Protectors and He is the Most Merciful of the merciful*

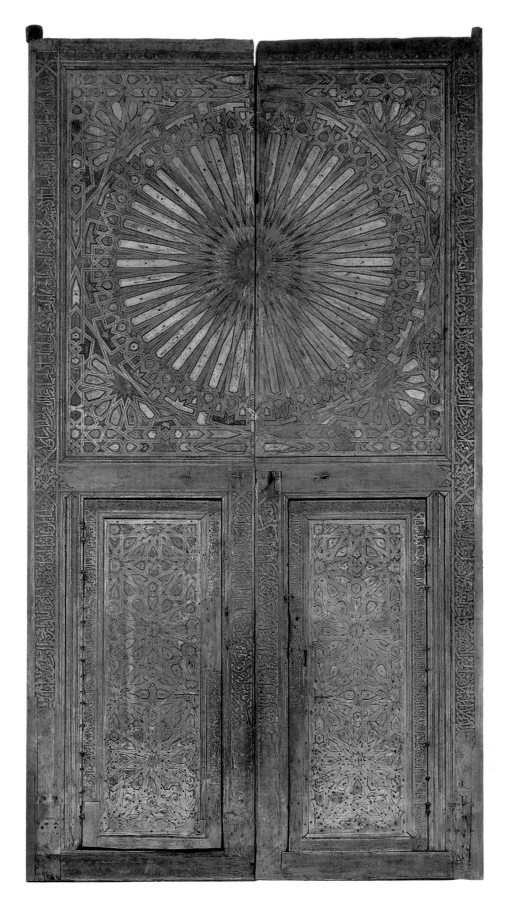

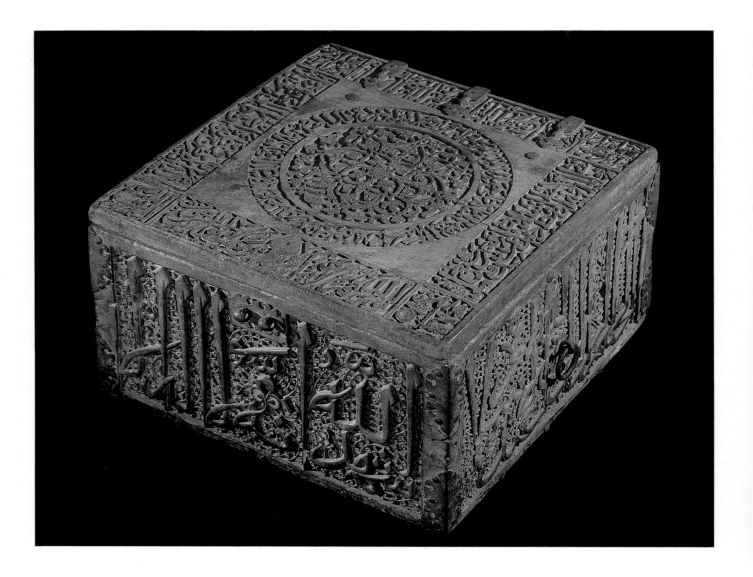

Box for a multi-volume manuscript of the Qur'ān
Wood, dadoed, mitred, dovetailed and painted
Iran, soon after mid Rajab 745 AH/c 23 November 1344 AD
Width 43 cm LNS 35 W

INSCRIBED AROUND SIDES OF BOX
Beginning with verse 18 and continuing into verse 19 of Chapter III of the Qur'ān

AROUND CIRCULAR MEDALLION ON TOP OF LID

وقف الصدر المكرّم ملك الصدقة والاكابر عزّ الدين ملك بن ناصر الله محمد دام علوه هذه
الختمة الشريفة المباركة على مصالح التربة [.sic] المرحوم فخر الدين (چوبان or چوبان؟)

The revered leader, king of charity and of the notables, 'Izz al-Dīn Malik, son of Nāṣir Allāh Muḥammad, [may God] prolong his exaltedness, entered this august, blessed complete copy of the Qur'ān into endowment for the benefit of the tomb of the deceased (received into God's mercy) Fakhr al-Dīn.

IN RECTANGULAR COMPARTMENTS AROUND PERIMETER OF LID

توفّى المذكور في أواسط رجب سنة خمس وأربعين وسبع مائة / نوّر الله قبره لا يباع ولا
يوهب ولا يورث إلى أن يرث / الله الارض ومَن عليها وهو خير الوارثين فَمَن بدّله بعد ما
سمعه / فإنّما إثمه على الذين يبدّلونه إن الله سميع عليم تمت

The mentioned one died in the middle of Rajab of the year five and forty and seven-hundred, may God light his tomb. It is not to be sold nor to be given nor to be inherited until God inherits the earth and those who are upon it, and He is the best of the inheritors. Surely, the offense of exchanging it after hearing this is on those who exchange it. Indeed, God is All-Hearing, All-Knowing. The end

IN SQUARE COMPARTMENTS AT CORNERS OF LID

هذا من صنائع / العبد الحقير الحسن بن / قتلومك بن المرحوم فخر الدين

This is among the works of the poor slave [of God] al-Ḥasan, son of Qutlūmak, son of the deceased Fakhr al-Dīn.

110

Late Islamic Period

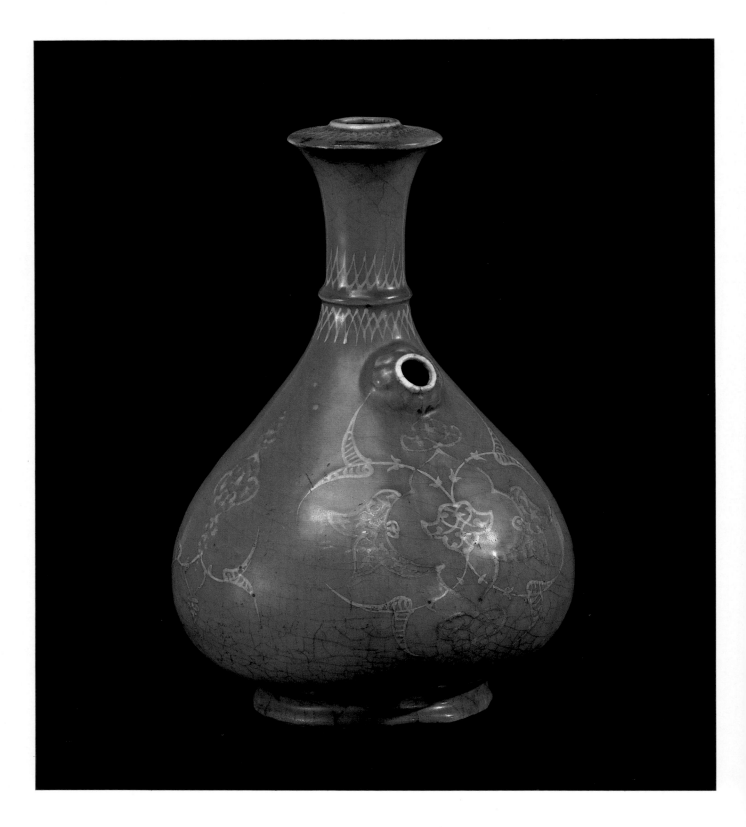

Kalian
Composite body, opaque blue frit, underglaze slip painted
Iran, seventeenth century AD
Height 32.5 cm LNS 171 C

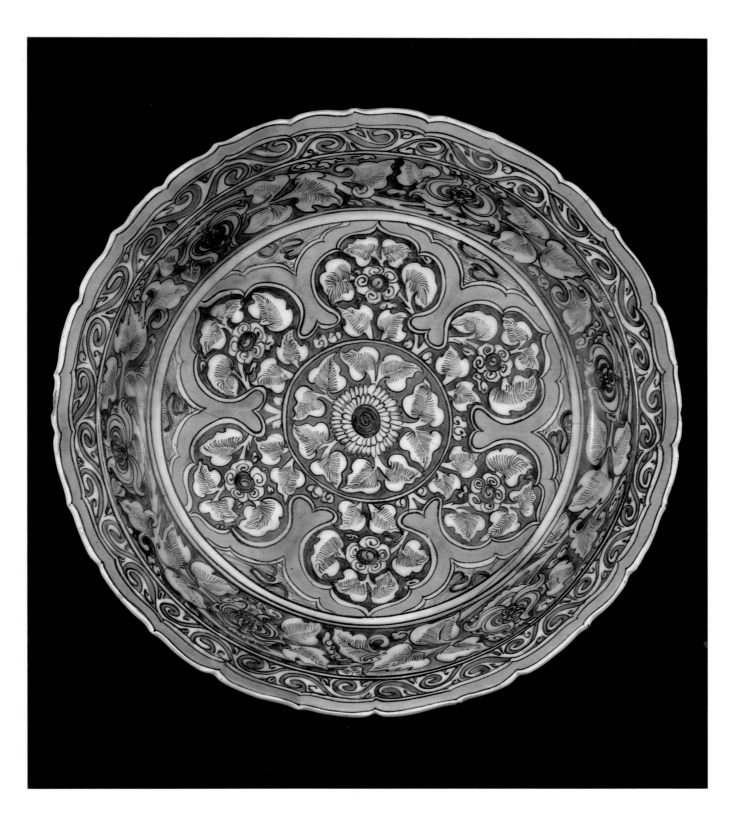

Dish
Composite body, underglaze painted
Iran, seventeenth century AD
Diameter 42 cm LNS 101 C

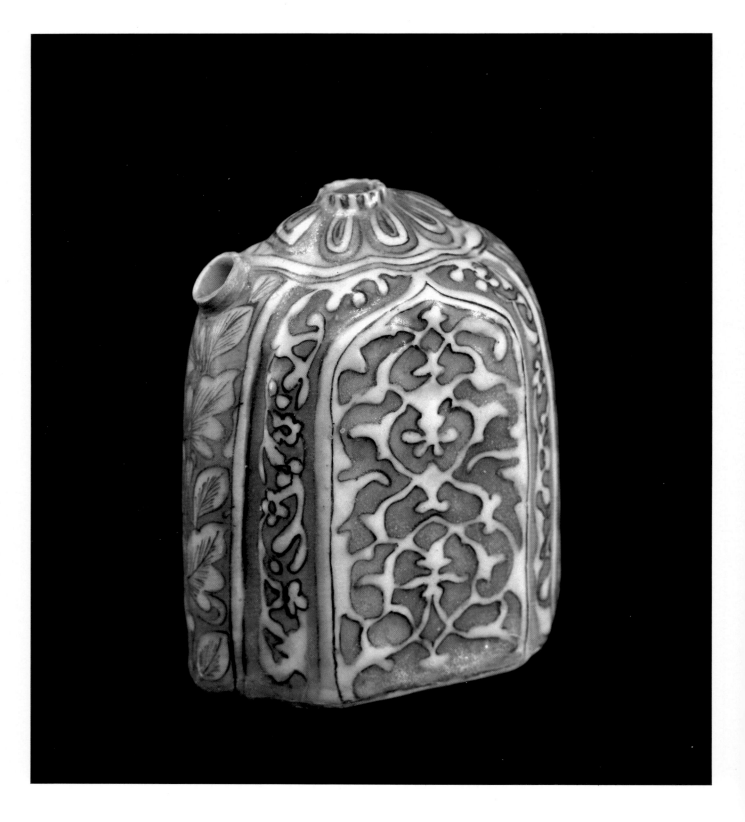

Kalian
Composite body, moulded and underglaze painted
Iran, seventeenth century AD
Height 11.3 cm LNS 117 C

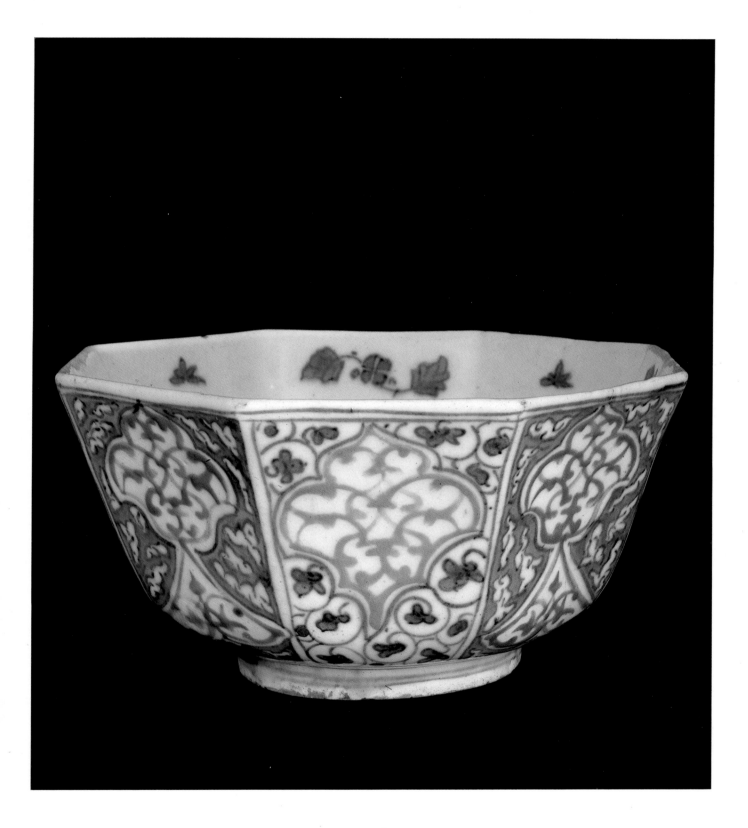

Bowl
Composite body, underglaze slip (?) and stain painted
Iran, seventeenth century AD
Diameter 19.5 cm LNS 130 C

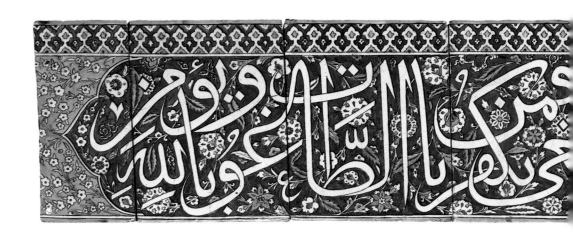

One of three border tiles
Composite body, opaque white glaze, underglaze painted
Turkey, Isnik, 1511 AD
Width 35.6 cm LNS 78 Cᵃ

116

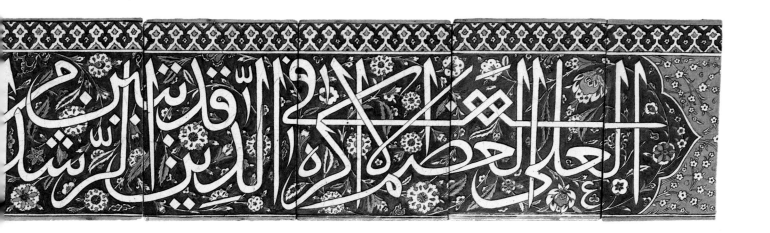

Panel of nine tiles
Composite body, opaque white glaze, underglaze slip and stain painted
Turkey, Isnik, second half sixteenth century AD
Length 239 cm LNS 154 ca–i

Inscription begins within verse 255 of Chapter II of the Qur'ān and continues into verse 256

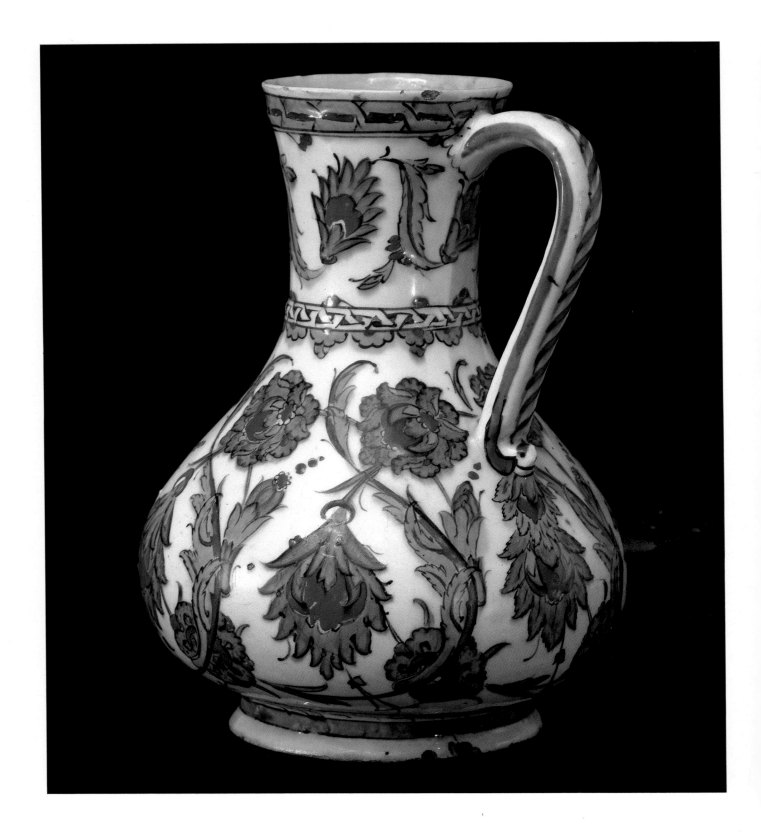

Ewer
Composite body, opaque white glaze, underglaze slip and stain painted
Turkey, Isnik, second half sixteenth century AD
Height 28 cm LNS 99 C

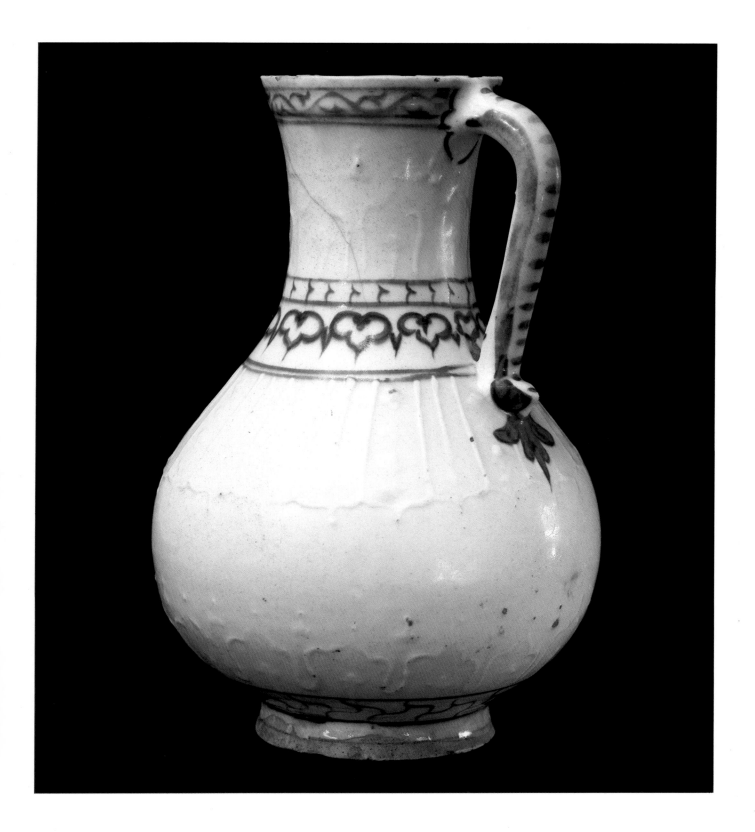

Ewer
Composite body, moulded, opaque white glaze, underglaze painted
Turkey, Isnik, *c* 1600 AD
Height 25.4 cm LNS 174 C

Two tiles
Composite body, opaque white glaze, underglaze slip and stain painted
Turkey, Isnik, third quarter sixteenth century AD
Width of each tile 22 cm LNS 16 C^{ab}

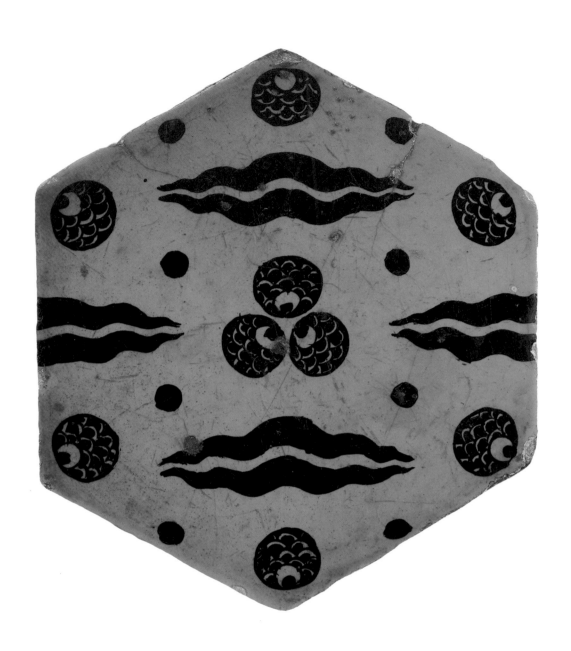

Tile
Composite body, underglaze painted
Syria, *c* 1600 AD
Greatest width 30 cm LNS 164 C

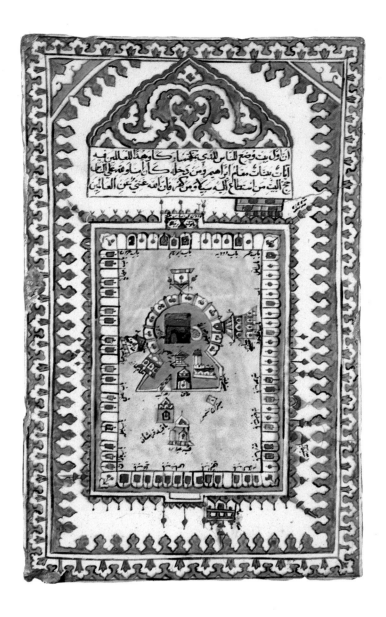

Tile panel
Composite body, opaque white glaze, underglaze slip and stain painted
Turkey, Isnik, *c* 1665 AD
Height 59.5 cm LNS 60 C

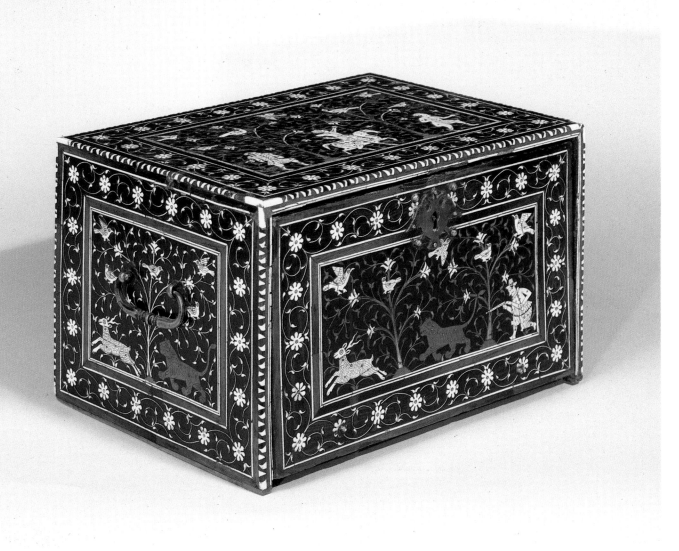

Travelling casket
Wood, mitred, dovetailed, inlaid with ivory (some stained in colours) and contrasting woods
North India, first half seventeenth century AD
Height 17.3 cm LNS 10 I

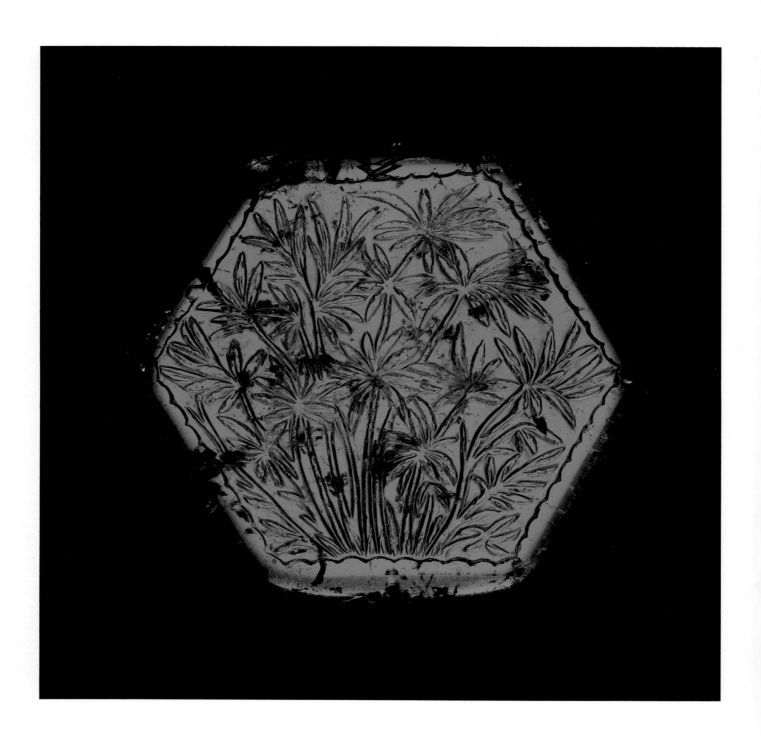

Centrepiece
Emerald, wheel cut and drilled
Mughal India, late sixteenth–early seventeenth century AD
Greatest width 5.7 cm; weight 234 carats LNS 28 HS

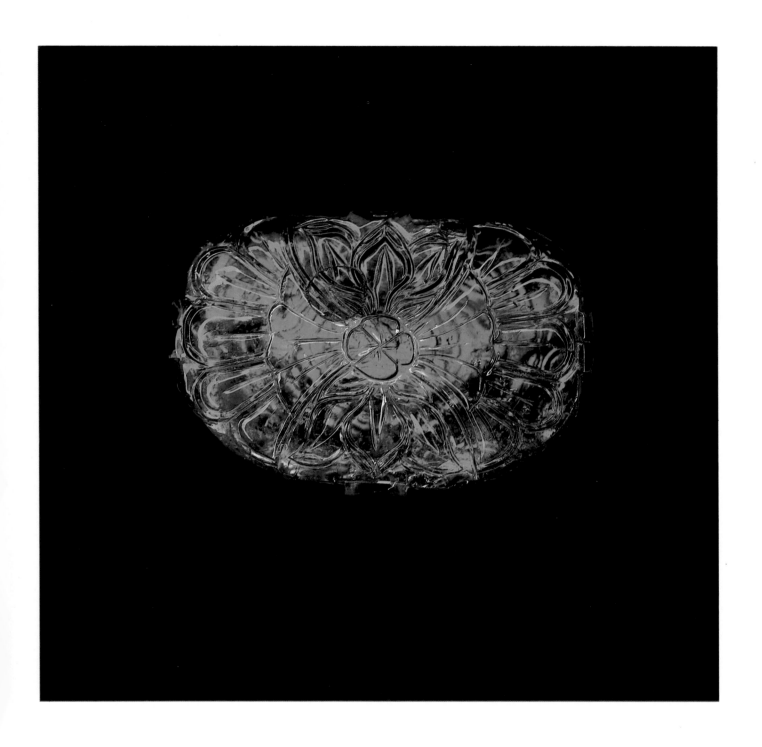

Centrepiece of an armband
Emerald, wheel cut and drilled
Mughal India, seventeenth century AD
Width 4.8 cm; weight 179.6 carats LNS 29 HS

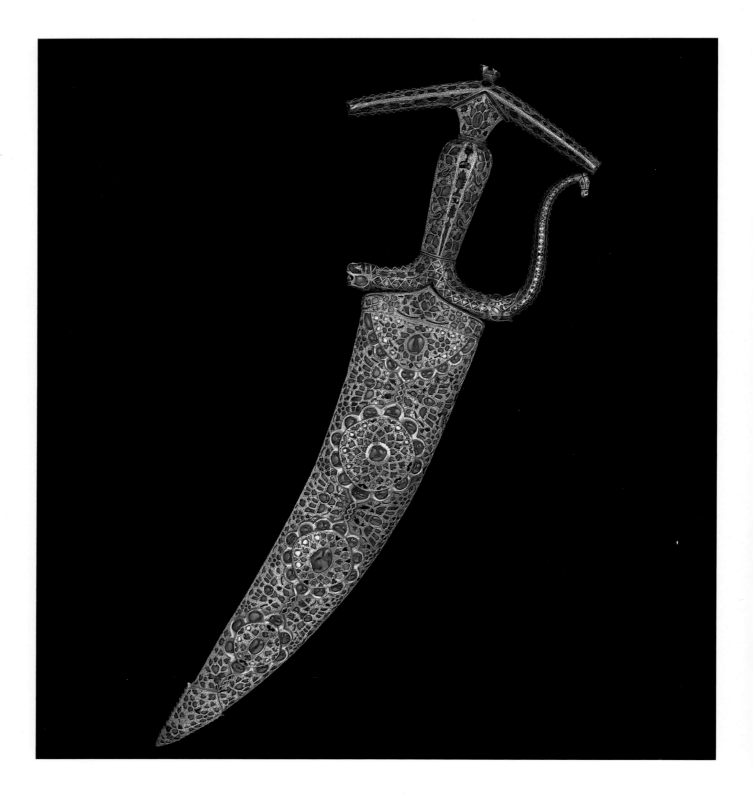

Dagger and scabbard
Steel blade, hatched and overlaid with gold; solid gold hilt, cast or wrought; wood scabbard, overlaid
with gold (back worked in *repoussé*); hilt and scabbard engraved and set with ivory, agate, natural
octahedral diamond crystals, rubies, emeralds and green glass, with touches of enamel
Mughal India, first quarter seventeenth century AD
Total length 35.5 cm LNS 25 J

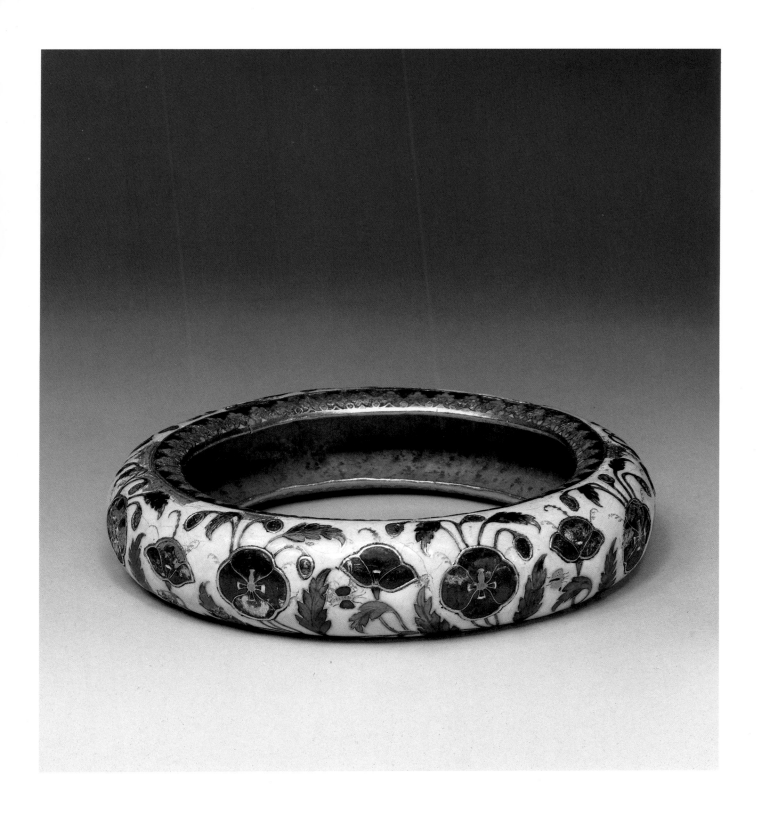

Ring to stabilise huqqa bowl
Gold, hammered, engraved and enamelled
Mughal India, *c* 1635
Diameter 14.5 cm LNS 2 J

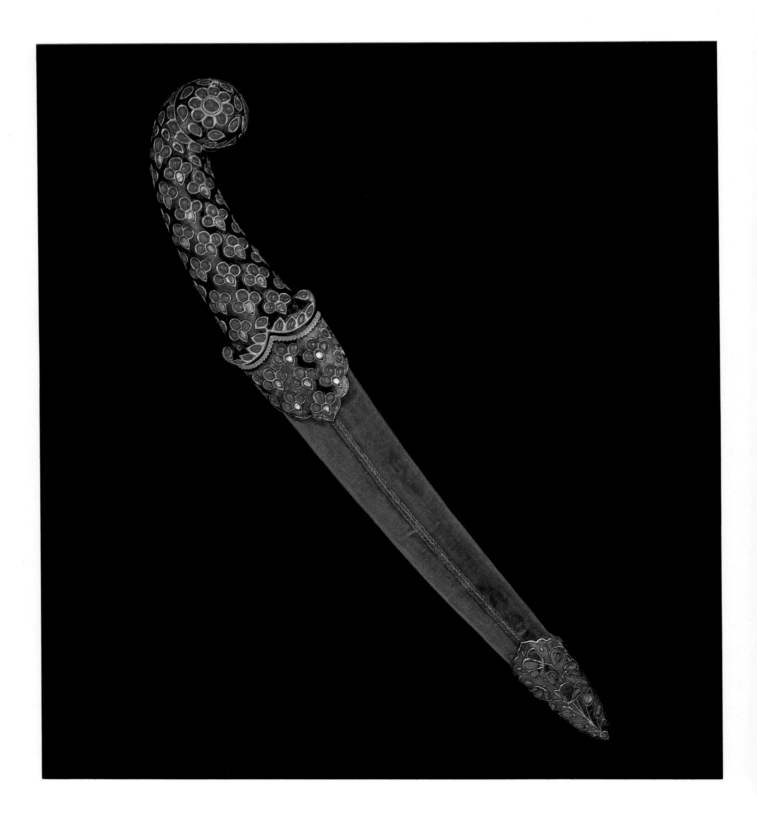

Dagger and scabbard
Steel blade (a late replacement); wood scabbard, covered with velvet; hilt, locket and chape, fabricated
from gold, engraved, enamelled and set with diamonds and rubies
Mughal India, second half seventeenth–eighteenth century AD
Total length 39.4 cm LNS 26 J

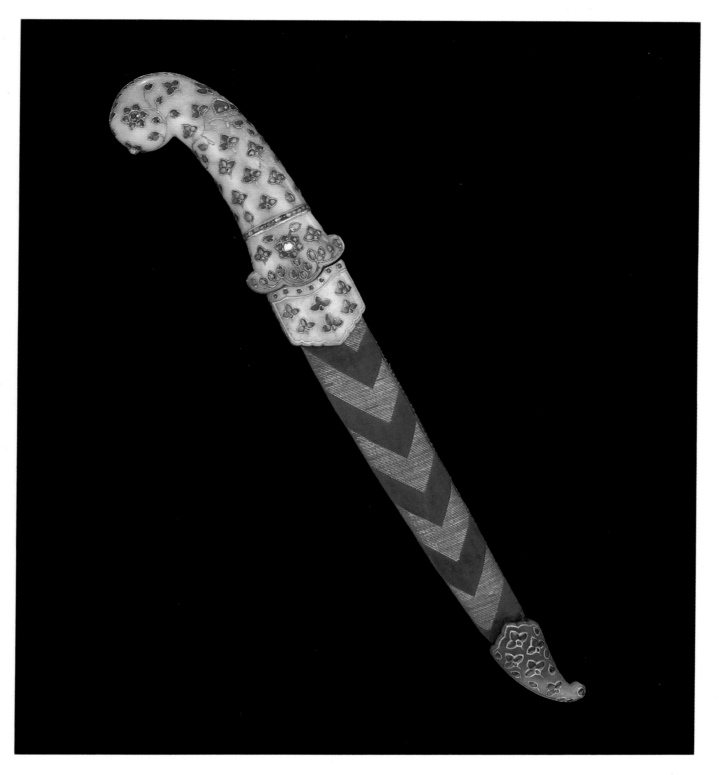

Dagger and scabbard
Steel blade; wood scabbard, covered with woven fabric; hilt, locket and chape, white jade,
inlaid with gold and set with fine stones
(hilt with diamonds, rubies and emeralds; locket and chape with rubies and emeralds)
Mughal India, first half seventeenth century AD
Total length 39.4 cm LNS 12 HS

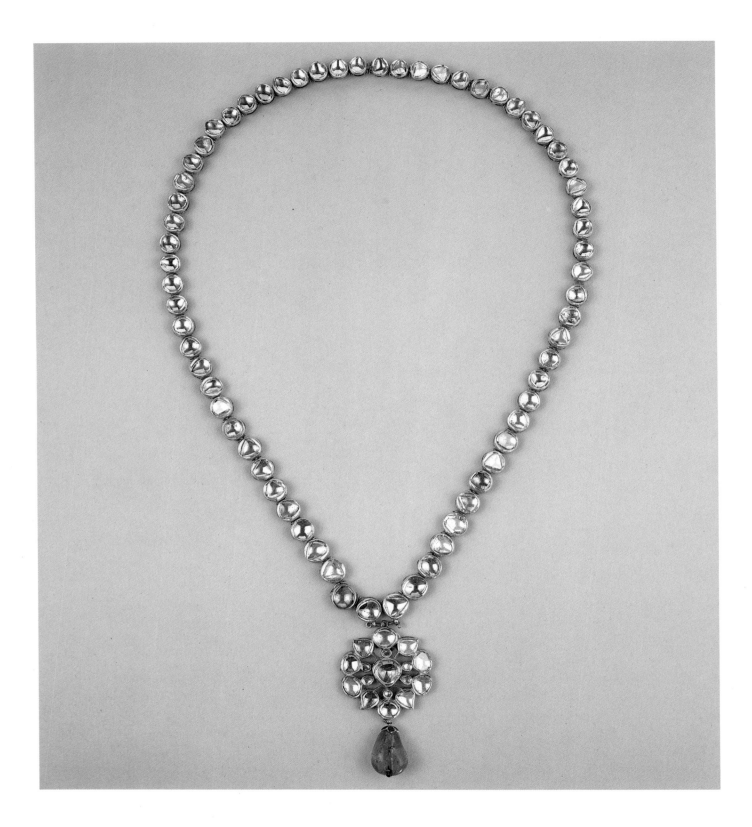

Necklace
Gold, fabricated from sheet and wire, set with diamonds and enamelled, pendent emerald
Mughal India, probably eighteenth century AD
Width of pendant 4.1 cm LNS 16 J

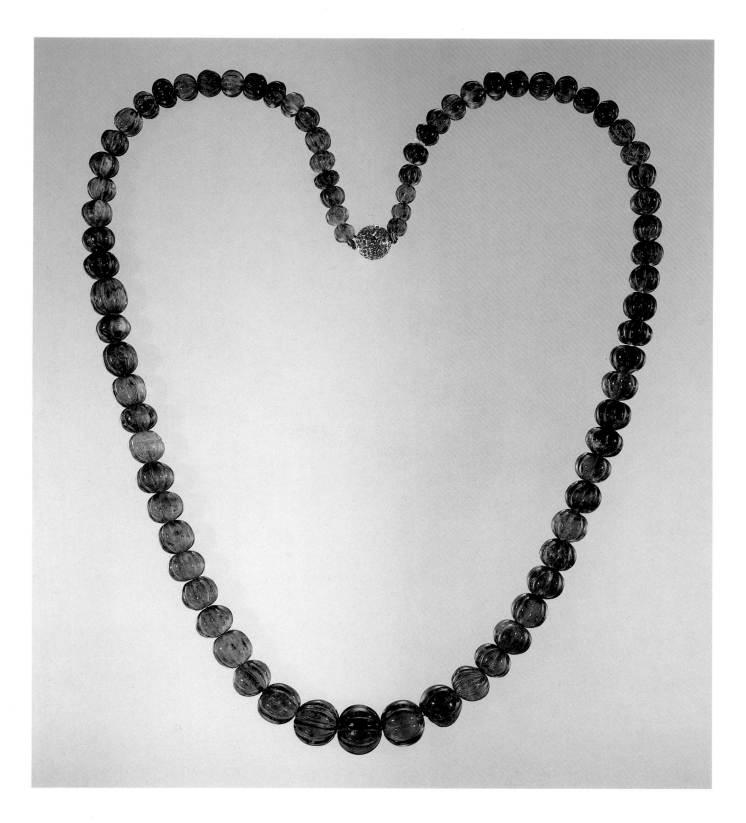

Necklace
Emerald, wheel cut and drilled
Mughal India, probably seventeenth–eighteenth century AD
Length 66 cm; total weight 530 carats LNS 30 HS

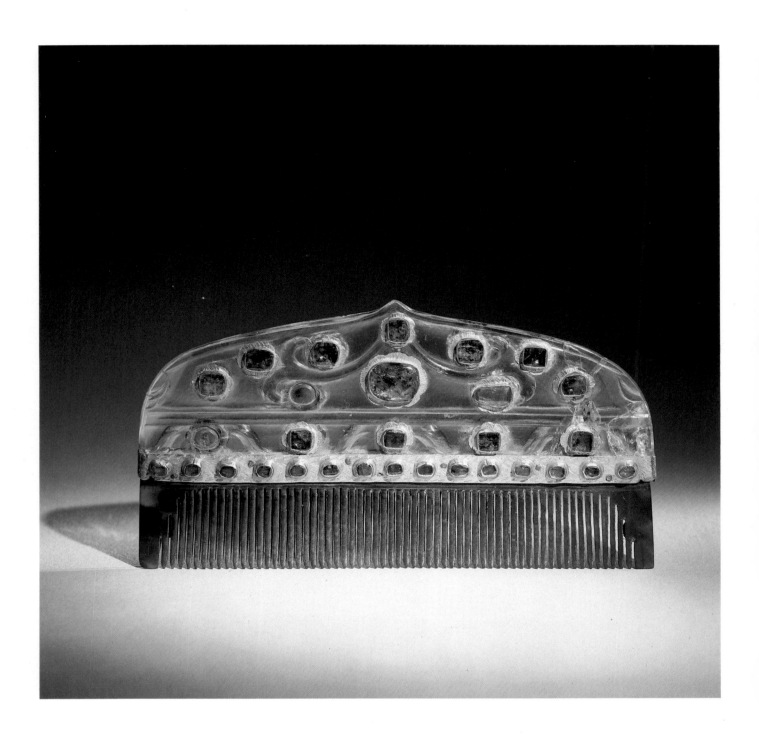

Comb handle
Rock crystal, carved, inlaid with gold and set with foiled stones, including emeralds and rubies;
gold ferrule set with foiled stones joins handle and comb
Turkey, seventeenth century AD
Length 12.7 cm LNS 7 HS

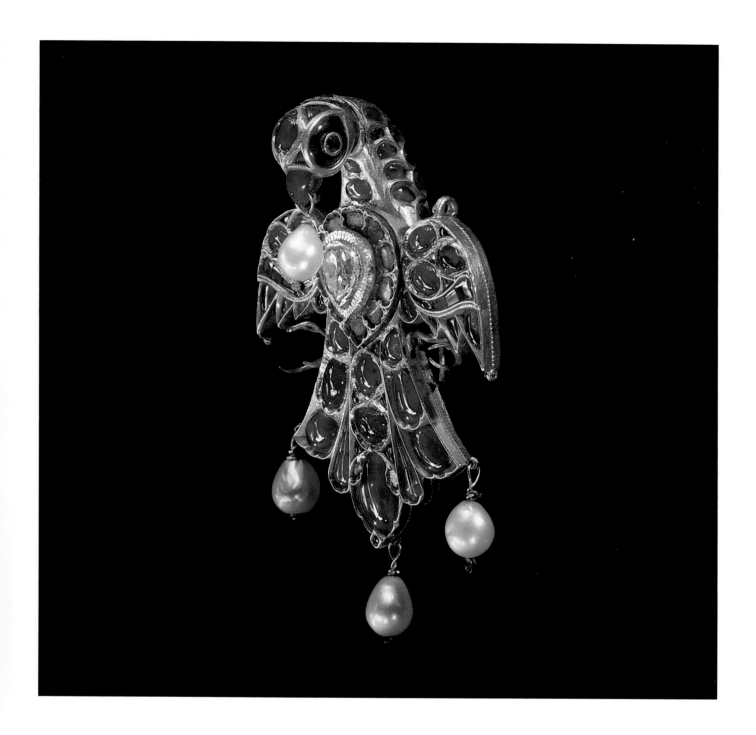

Pendant
Gold, fabricated from sheet and wire, engraved, inlaid with niello, set with rubies, diamonds, emeralds
and foiled rock crystal; pendent pearls
North India, probably eighteenth century AD
Height with pendent pearl 9.3 cm LNS 28 J

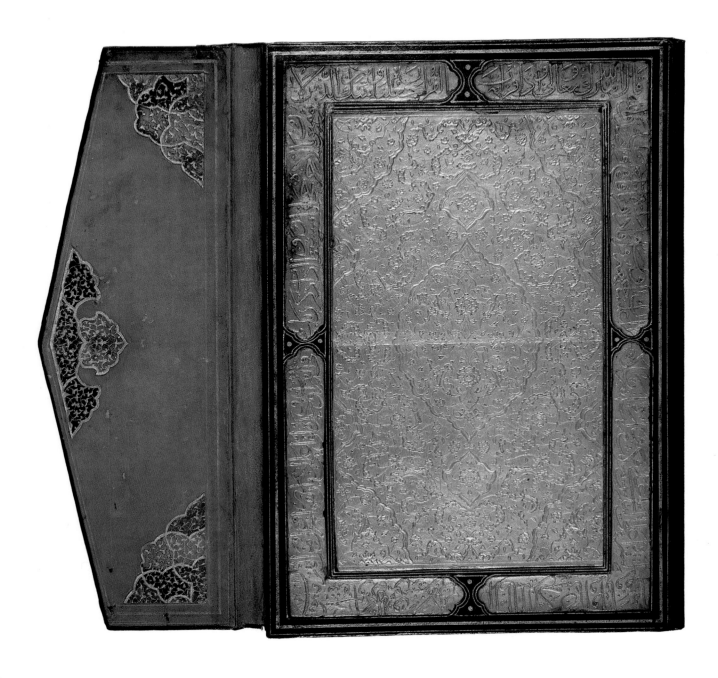

Fourteenth 'Juz'' from a Qur'ān manuscript with original binding
Manuscript: ink, colours and gold on paper; binding: embossed and cut leather,
overlaid with colours and gilt
Iran, sixteenth century AD
Height of binding 35.5 cm LNS 10 L

*Manuscript contains Chapters XV and XVI, binding is inscribed with Chapter XVII verse 45 to last half 46, 82 and 106; and Chapter
LXXV verse 17, all of which have to do with the obligation to read the Qur'ān and the blessings associated with doing so*

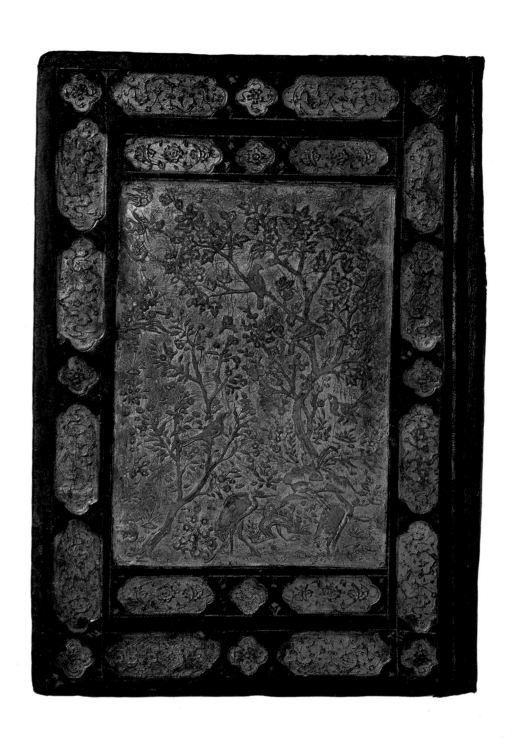

Binding from a manuscript
Leather, moulded and gilt
Iran, first half sixteenth century AD
Height 37.2 cm LNS I I L

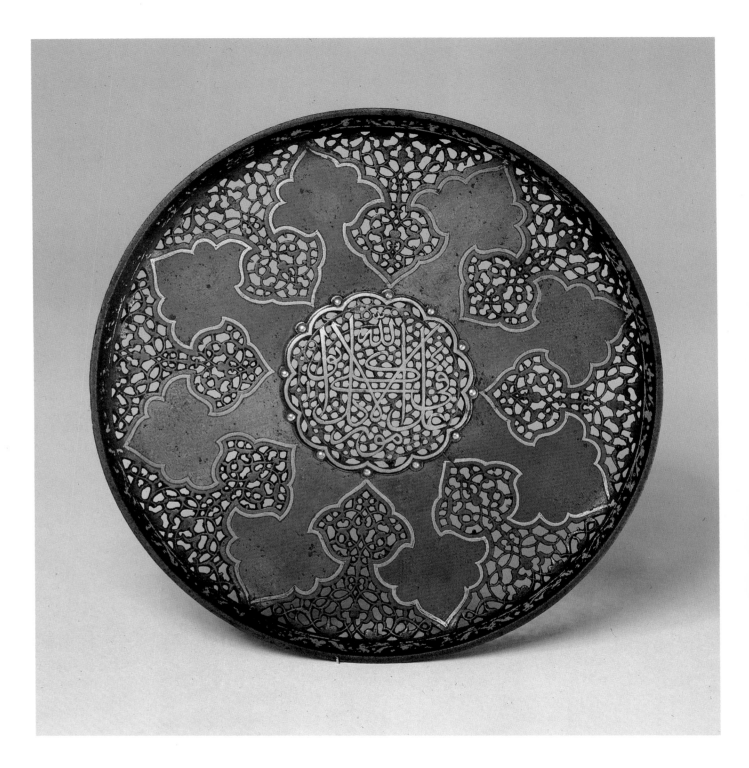

Roundel
Steel, pattern welded, hammered to shape, acid-etched (openwork), engraved, inlaid, hatched and
overlaid with gold
Iran, probably eighteenth century AD
Diameter 13.8 cm LNS 137 M

INSCRIBED
توكّل على الله فى كل الامور *Rely on God in all matters*

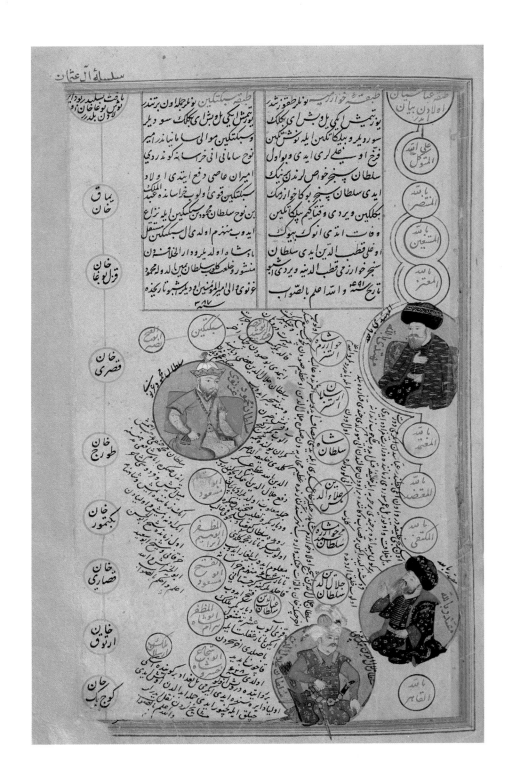

Leaf from a 'Zubdat al-Tawārīkh' manuscript
Ink, colours and gold on paper
Turkey, *c* 1580 AD
Height 24.5 cm LNS 66 MS

INSCRIBED AT TOP
سلسلة آل عثمان *Genealogy of the House of 'Uthmān*

137

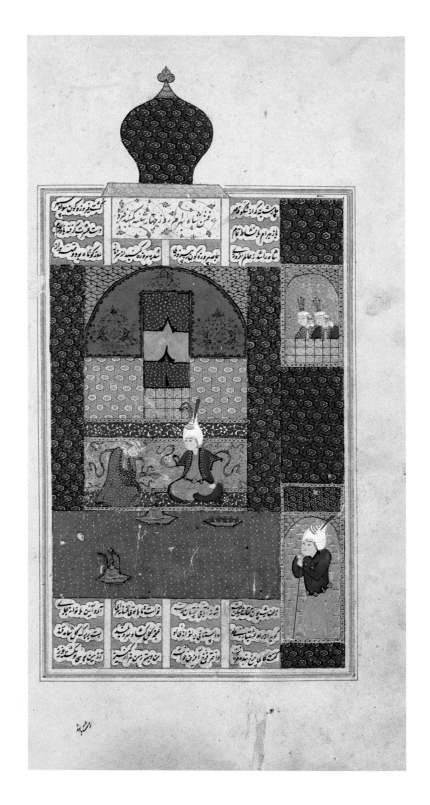

Bahram Gur in the Blue Pavilion
Miniature from a manuscript of the *Khamseh* by Nizami
Ink, colours and gold on paper
Iran, Shiraz, dated Shaʿbān 943 AH/January 1537 AD
Height of page 30.6 cm LNS 4 MS

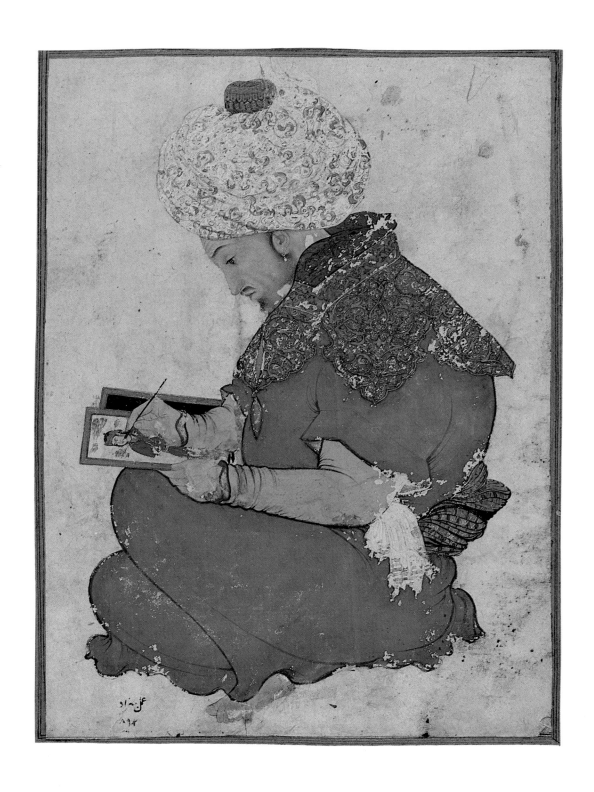

Portrait of a Persian painter
Ink, colours and gold on paper
Mughal India, first quarter seventeenth century AD
Height of page 31 cm LNS 57 MS

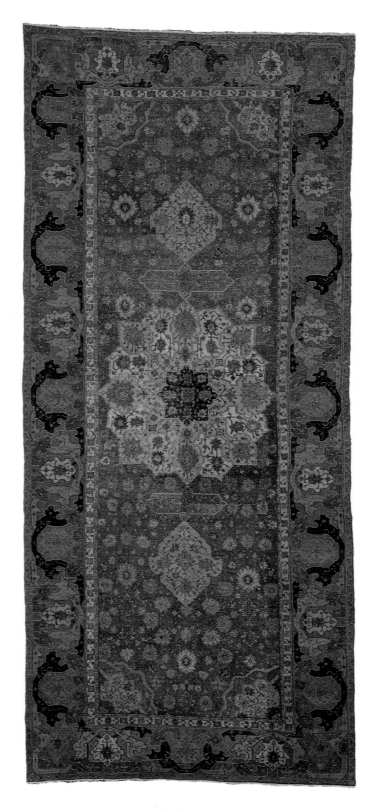

Medallion carpet
Wool and cotton
Iran, Tabriz, second quarter sixteenth century AD
Length 706 cm LNS 28 R

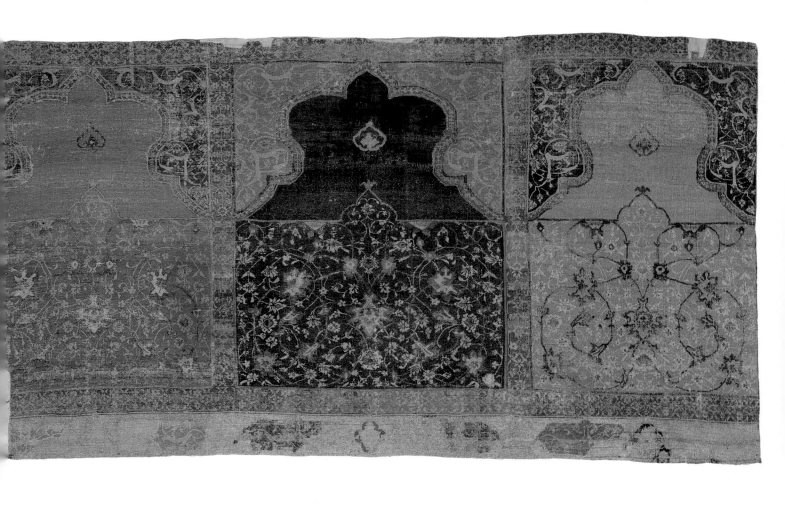

Multiple-niche prayer rug
Wool
Iran, beginning sixteenth century AD
Width 263 cm LNS 27 R

141

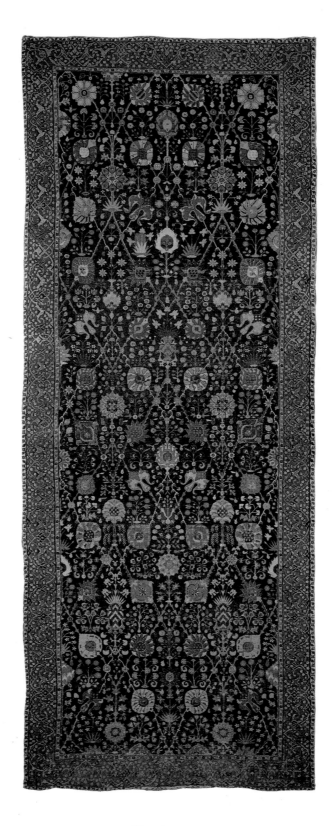

'Vase' carpet
Cotton warp, wool weft and pile
Iran, probably Kirman, late seventeenth–eighteenth century AD
Length 538 cm LNS 25 R

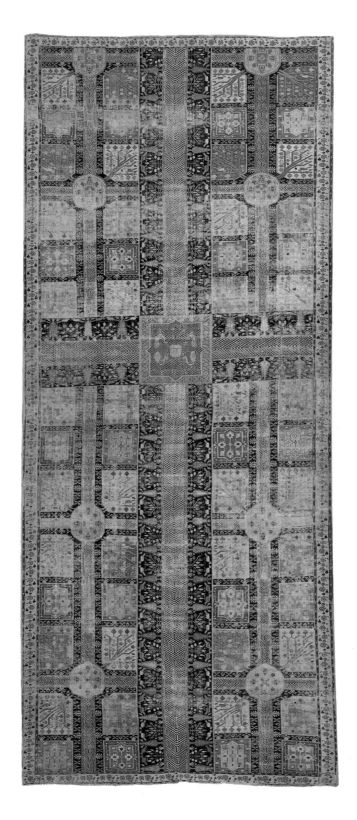

'Garden' carpet
Wool
Northwest Iran, eighteenth century AD
Length 925 cm LNS 10 R

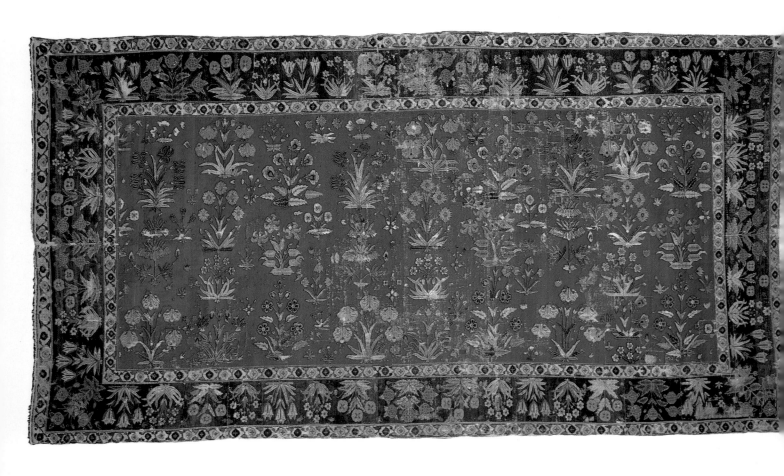

Carpet
Cotton warp and weft and wool pile
India, seventeenth century AD
Width 508 cm LNS I 5 R

144

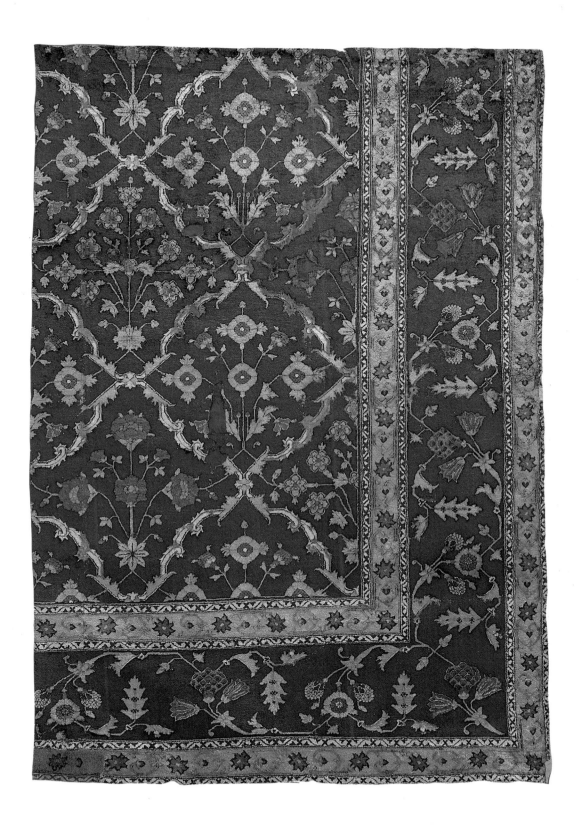

Carpet fragment
Silk
Northern India, Hyderabad, seventeenth century AD
Length 190 cm LNS 20 R

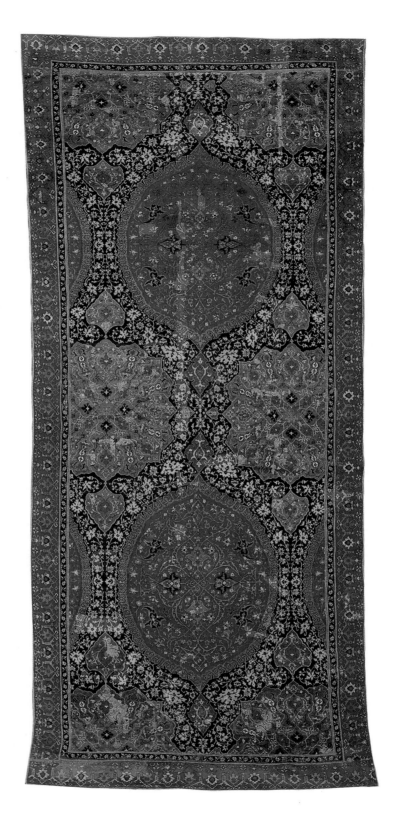

'Medallion Ushak' carpet
Wool
Turkey, Ushak, seventeenth century AD
Length 723 cm LNS 26 R

146

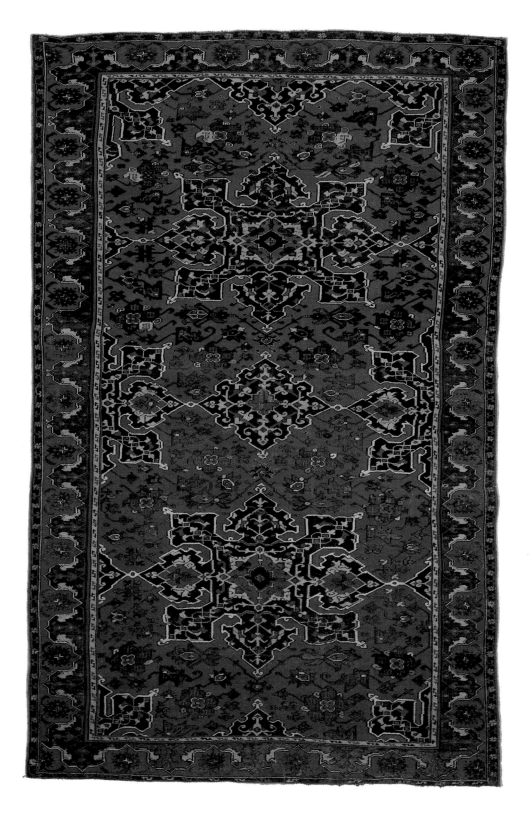

'Star Ushak' carpet
Wool
Turkey, Ushak, seventeenth century AD
Length 286 cm LNS 17 R

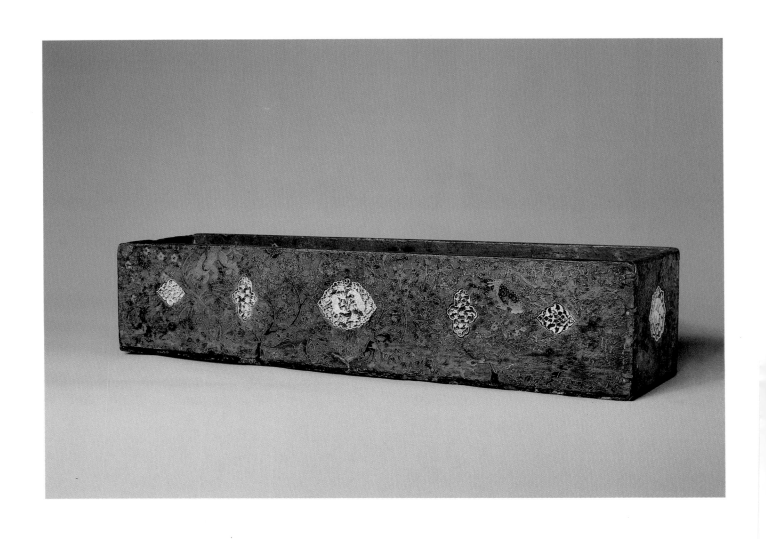

Bottom of box
Wood, mitred, dovetailed, painted (lacquered?) and inlaid with carved and gilded ivory plaques
Iran, second half sixteenth century AD
Length 39.4 cm LNS 31 W

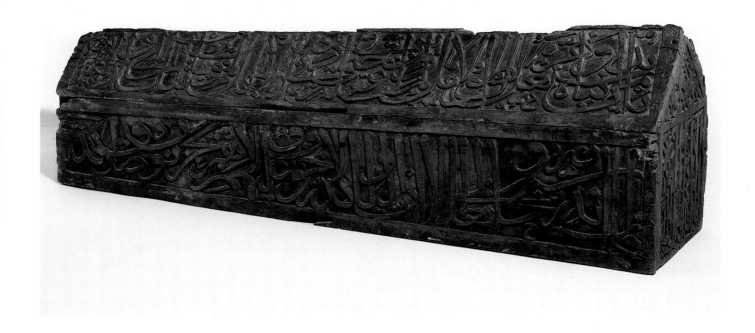

Cenotaph
Carved wood
Turkey, perhaps fifteenth century AD
Length 140 cm LNS 8 W

Inscriptions consist of pious phrases, exhortations, reminders of human mortality and God's wisdom and sovereignty, as well as reassurances for those who are close to God

151

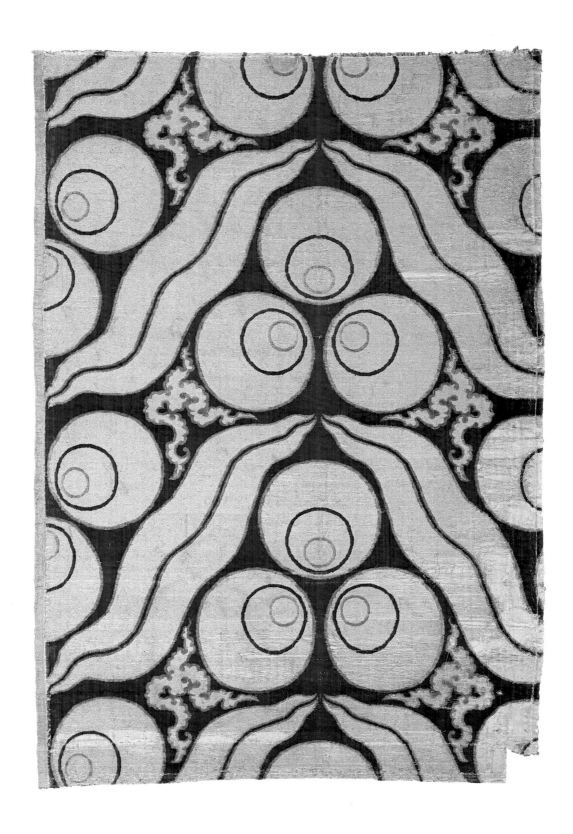

Cushion cover fragment
Silk velvet, cut and voided with brocaded silver thread
Turkey, first half sixteenth century AD
Height 86 cm LNS 11 T

152

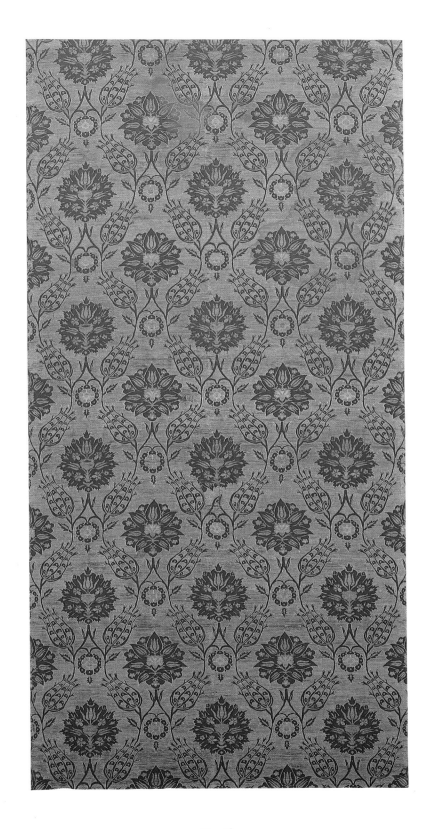

Textile
Silk and metallic threads
Turkey, seventeenth century AD
Length 131 cm LNS 105 T

153

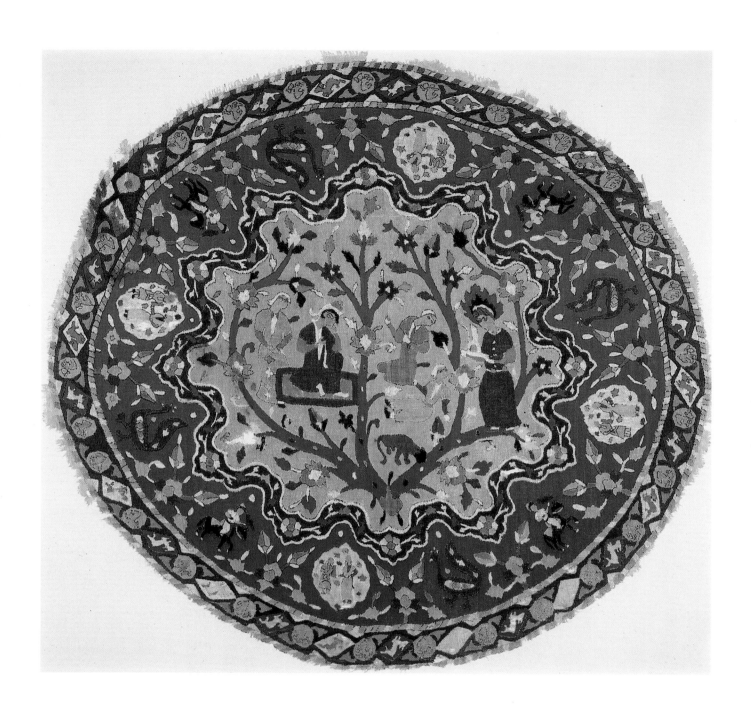

Roundel
Cotton with silk embroidery
Iran, *c* 1625 AD
Diameter 89 cm LNS 37 T

154

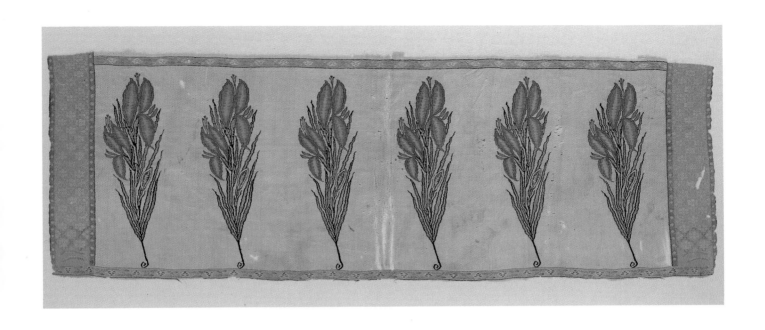

Patka fragment
Wool
India, Kashmir, mid seventeenth century AD
Width 67.3 cm LNS 59 T

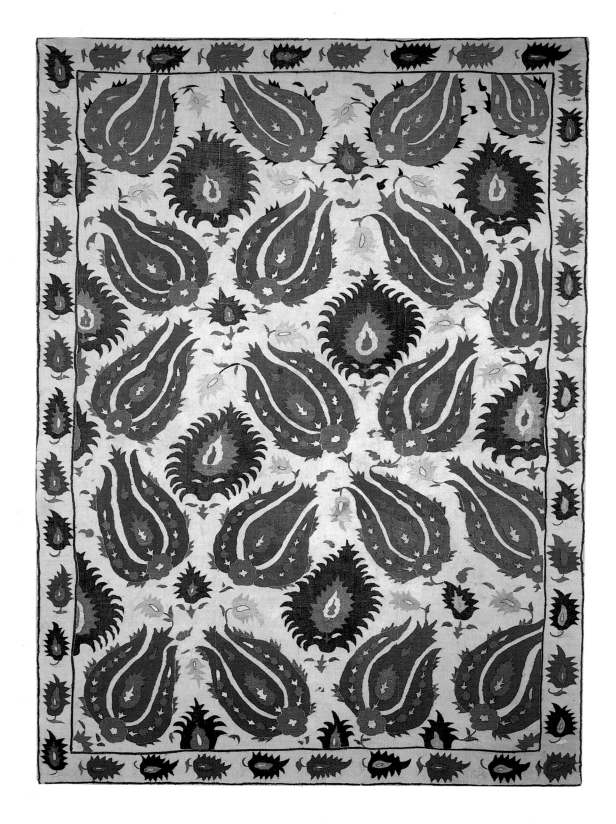

Panel
Cotton with silk embroidery
Turkey, eighteenth century AD
Height 190 cm LNS 98 T

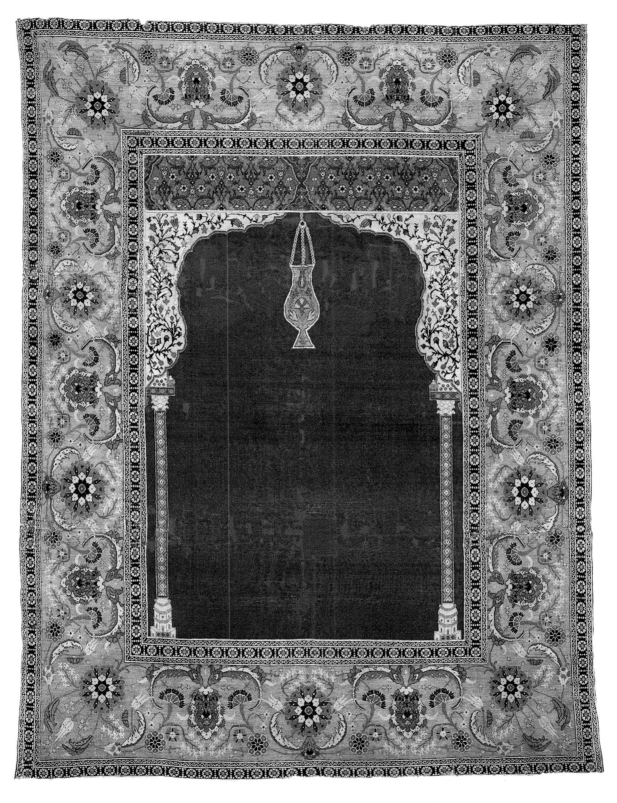

Prayer rug
Wool, cotton and silk
Turkey, probably Bursa, late sixteenth century AD
Length 172 cm LNS 29 R

157